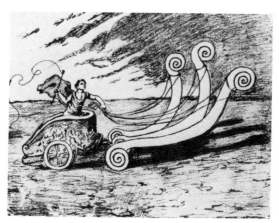

The Invincible Chariot
1969
lithograph

LATE

An Exhibition organised by Arnolfini Gallery, Bristol

Edited by Rupert Martin

DE CHIRICO

1940-76

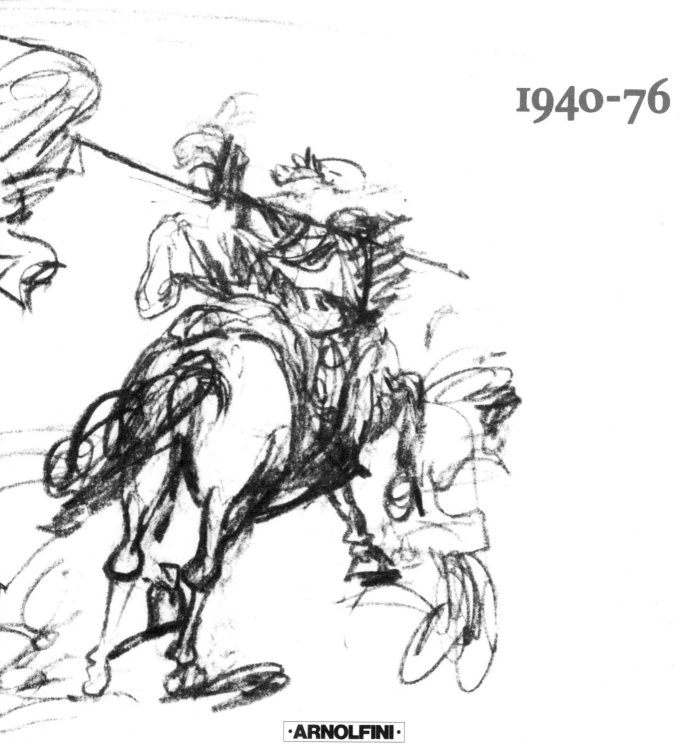

·ARNOLFINI·

Preface

*Painting concerns us as much for its material and technical side
as for its enigmatic and disturbing aspect.
The one side enriches the other and makes painting
worthy of existence.*

Giorgio de Chirico:
Statues, Furniture and Generals in *Bulletin de l'Effort Moderne*,
Paris, 1927

A remarkable unity of vision and technique is apparent in the late work of Giorgio de Chirico, in which the metaphysical insights of the early years are combined with the technical skills acquired during the 1920s and '30s. De Chirico, by his own admission, never abandoned his early metaphysical ideals, when, inspired by the writings of Nietzsche and Schopenhauer, he sought to depict the spiritual and spectral aspect of everyday things. Throughout the vagaries of style and the pursuit of technical excellence this nostalgia for the infinite persists, and the different idioms in which he worked can be reconciled within the framework of de Chirico's consistent adherence to the truth of 'revelation', about which he wrote in 1935:

Revelation is something which appears suddenly to the artist, as if a curtain had been drawn aside or a door opened; giving him great joy and great happiness, an almost physical delight and the power to work.[2]

This exhibition presents a selection of de Chirico's work from 1940–76, and traces the late flowering of his creativity from the portraits and 'antique landscapes' of the 1940s to the inventive 'neo-metaphysical' paintings of the 1970s. The strength of de Chirico's vision is such that the late work has inspired contemporary artists in the same way that the early work influenced the Surrealists. In the light of these recent developments it is possible to see an artist, who was ahead of his time, and whose disquieting vision is at the same time a fitting reflection of his age. Like Picasso and Guston, de Chirico was able radically to renew his painting without rejecting his past inspiration, and this capacity for innovation, which manifests itself in the splendour of late paintings such as *The Mysterious Animal* or *The Remorse of Orestes*, enhances rather than undermines the integrity of his work.

On behalf of Arnolfini Gallery I would like to thank Signora Isabella Far de Chirico for her keen support of this exhibition and her generous loan of drawings and graphic works. I would also like to thank Artcurial and other private lenders for their generosity in making works available for this exhibition. Special thanks are due to Carmine Siniscalco of Studio-S/Arte Contemporanea, Rome, for his invaluable help in the organisation of the exhibition and the preparation of the catalogue. Thanks are also due to M. Guy Landon, President-Director General of Artcurial, to Mme Tessa Herold, Director; and to M. Jacques Buchi for their help in arranging loans.

I would like to thank those who have contributed to the catalogue; Maurizio Calvesi, Maurizio Fagiolo dell'Arco, Stephen McKenna and Wieland Schmied for their illuminating essays, and Richard Hollis for his design work.

The exhibition will be shown at the Museum of Modern Art, Oxford, at the Mappin Art Gallery, Sheffield and at the Riverside Studios, London, and I would like to thank my colleagues at those venues for their collaboration in this showing of the late work of de Chirico in England. I would also like to thank Norman Rosenthal, David Sylvester and Sarah Whitfield for their help and encouragement during the formative stages of this exhibition.

Arnolfini gratefully acknowledges the financial assistance of the Arts Council of Great Britain, South West Arts and Bristol City Council. Thanks are also due to *London Life* for their generous sponsorship.

Finally I would like to thank my colleagues at the Arnolfini; Jeremy Rees, Andrea Schlieker, Claire Anderson, John Christopher, Jenny Lockwood and George Coulsting, for their invaluable assistance in the preparation and installation of this exhibition.

Rupert Martin
Gallery Co-ordinator

1. Giorgio de Chirico: *Quelques Perspectives sur Mon Art* in
L'Europe Centrale, no.17, 27 April 1935, pp.266–269

Contents

7

Isabella Far de Chirico: Foreword

8

Maurizio Calvesi: Introduction

9

Maurizio Fagiolo dell'Arco: **The Last Individualist**

10

Stephen McKenna: **Pictor Classicus Sum: Giorgio de Chirico, Integrity and Reaction**

15

Wieland Schmied: **Unity and Variety in the Work of Giorgio de Chirico: A Personal Memoir**

49

Maurizio Fagiolo dell'Arco: **Eight Selected Paintings**

51

Giorgio de Chirico: Selected Texts

52

Carmine Siniscalco: Biographical Notes

56

Catalogue

62

Selected Bibliography

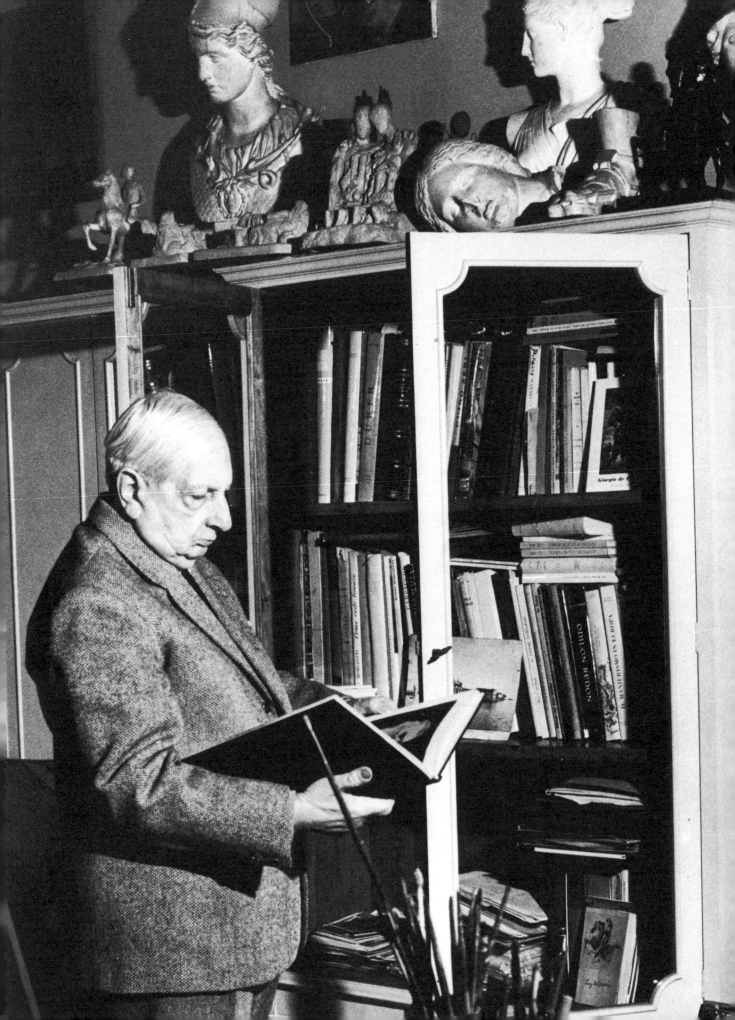

Foreword

When the Arnolfini Gallery of Bristol, a non-profit-making enterprise, told me of their plans for putting on an exhibition in England dedicated to the post-1940 works of Giorgio de Chirico and designed to show them in their proper light and context, I readily agreed to contribute drawings and graphic works from my personal collection; because for too long the artist's output of his last forty years has been neglected and misunderstood, particularly by the Italian critics who – with a few authoritative exceptions – have not grasped that his works should be studied as a whole, as the expression of a way of being and thinking, and not subdivided into a series of historical periods neatly labelled for the convenience of dealers. The latter practice is too easy, too convenient and above all unjust. I, who lived for fifty years at the side of Giorgio de Chirico, know that my husband worked consistently and pertinaciously, painting at any given time only what he wanted to paint. He could be working during the same period on a classical portrait, a Rubenesque nude, a Metaphysical vision, a *Piazza d'Italia,* a rampant horse or a still life of 17th-century inspiration. If one looks closely at de Chirico's work, and above all if one looks at it intelligently, one sees that there is not a chronological progression; one sees that the painting of de Chirico is, above all, the thought of de Chirico. Over the years the technique is perfected, and along with the repetition of various key motifs one discovers some new elements of inspiration, but the essence is the same.

Having previously been opposed in principle or ignored, this way of reading de Chirico's work has begun to make headway in Italy. De Chirico has always been more loved by the public and by poets than by the professional critics. Some have always taken offence because he has never sought to ingratiate himself by descending from his lofty artist's pedestal. The fact that de Chirico today is internationally recognized as a cornerstone of 20th-century art is even now not unanimously accepted by the critics in Italy. However, the many opposing voices of some years back have now been reduced to modest proportions and comprise mainly the death-rattles of a few professors who with academic precision persist in their usual misappraisals and wrong attributions. I must acknowledge that the French critics have for some time now adopted the rule of reading de Chirico's works in their totality. A proof of this is the interest with which the French press followed the exhibition of de Chirico's post-1940s Metaphysical works presented at Artcurial in Paris, entitled 'The Return of the Prodigal Son', and timed to coincide with the exhibition organized at the Centre Georges Pompidou.

I am very happy that in 1985 this 'prodigal son' should, after years of absence, disembark in Great Britain to meet the British critics and public, who I am sure will welcome the chance to deepen and extend their acquaintance with his complex and unique artistic personality.

Isabella Far de Chirico

Giorgio de Chirico
in his Rome studio,
Piazza di Spagna

Maurizio Calvesi
Introduction

Metaphysical, neo-Baroque, traditionalist, polemicist, punster, paradoxer, banal, Nietzschean, petit-bourgeois, sublime, mediocre, limpid, opaque... these are all words that have been used when talking about de Chirico, his attitudes, his thinking, his behaviour and his art; and whoever wishes to find a common denominator among such a welter of apparent contradiction would probably do well to look into the depths of the artist's solitude and distance from the world – a kind of void which he sometimes filled with resounding success and sometimes (almost!) returned to its original state of emptiness. Searching for this common denominator is a valid exercise because it allows us to take the artist as a whole – a whole that stands up in its own right, significant and coherent even in its weaknesses; because the artist was consistent with each gesture in erasing sense from reality, or reflecting reality in a blank mirror, or reducing it to terms of the utmost banality or subterfuge lacking in any kind of imagination – alternating between nihilism and a dangerous courtship of nullity, between a sense of insignificance and no sense at all.

In saying this I perhaps (in fact, certainly) exaggerate but my intention is to sidestep all those tedious attempts to measure and weigh up de Chirico stroke by stroke and period by period, drawing distinctions at a level of poetry, quality or often only of taste between what is indistinguishable at a level of ideology. And if we focus on this ideology (as has been tried in recent essays) using it as exclusive material for moralistic analysis, that too could be unprofitable since we may find ourselves – even today! – tearing it to shreds, which would be to reckon without the fact that much of de Chirico's painting (and not only his Metaphysical painting) is of an overwhelming beauty.

Certainly there are banalities (including the pictorial ones) but they are an integral part of his poetry, and here he differed from the Surrealists. Intrinsic to the Surrealists were the most authentic and subtle paradoxes (extending also to their behaviour) programmed and finalized – as were all their researches into the unconscious, the disjunctive, the absurd – with the aim of capturing a reality more vivid and highly charged than reality itself. De Chirico, for his part, was diametrically opposed to all this. Behind the apparent absence of sense in his pictures he does not admit to any deeper sense; in fact he is almost indifferent to its existence (unless it be some sense which transcends comprehension or time). He does not admit to a profound sense any more than he accepts the utility or possibility of sense in a completely senseless world – a world which is at the same time supremely enigmatic and banal, a deception that deserves to be repaid in its own coin.

To choose the métier of painter is in itself to choose deception. Painting is an art that deceives the senses and it is an activity perfectly suited to the man or superman or genius who alone would order reality instead of being its victim and slave like any other human being. So it is an art perfectly adapted to the master of deception. And if this deception – that is to say painting – is the only reality, other types of deception may be pressed into service for the general good of which our genius the author will be the sole judge. Since deception is not objected to in principle, is there any harm in it at this inferior level?

The harm lies in the risk of pure utilitarianism, and de Chirico paid the price in a real and profound contradiction: faith in an art of conceptual and perceptual deception which therefore deceives and contradicts itself at the moment it becomes the object or pivot of a certainty that thinks it is not deceiving itself; that thinks the world is miserable and mean but does not think this of art – or at least the kind of art that by deceiving deception transcends deceptive history and the deceptive world. So we have the apparent changes, the shifts in attitude, the temporal adjustments (even in the 'dates' of the pictures) which are considered to be without any real importance, not so much because they are part of a great game of concealment but because as deceptions they are merely quantitive and can neither undermine nor relativize the unique certainty which is the homogeneous and lasting quality and the centrality of the creator's art.

This art – the deception which transcends the deception of the relative or any process of change – is concerned only with being in the absolute, immutable and eternal existence. So after his Metaphysical painting, which revealed the deceptiveness of the material world but which at the same time affirmed the transcendence of art, where had de Chirico to go except back to traditional values which embodied the perenniality of art? But by then the various avant-garde movements had for some time been opening up art's traditional frontiers, restating its terms and transferring its certainties to faith in the world, to faith in politics and history.

Hegel foretold that art would die to live again in philosophy. To this de Chirico replied with the hypothesis that philosophy would die to live again in art. The Futurists envisaged a participatory 'artocracy' in which the spectator would be at the centre of the picture. De Chirico envisaged an exclusive art, closely defending its purity and uniquely surviving in a world of ruin and decay.

Maurizio Fagiolo dell'Arco
The Last Individualist

In ploughing his furrow through the present century, Giorgio de Chirico has triumphed as the last great individualist. He has shown successfully that the artist can (or should) calmly follow the thread of Ariadne that exists in his own mind, incomprehensible though the results may be to others. He can paint the Acropolis in Athens or horses on the shore of the Thessalian sea; he can portray archaeologists and noonday piazzas, or tailors' dummies in the manner of Greek statues, or interiors so crammed with objects as to resemble the infinite; he can depict set-squares and pear-shapes, a man and his shadow, a wayfarer and his ghost. He can explore the Renaissance and the Baroque. He can study the Flemish painters or the great Michelangelo, or he can turn back to his own former styles. And for decades everyone has been continually astonished by (and disapproving of) this disquieting ubiquity. No sooner do they have their man neatly pigeonholed than the Metaphysician is off on another tack. And the Master of Enigmas, to preserve the spirit of contradiction, then goes and repudiates everything.

'One must discover the daemon in everything,' was de Chirico's first commandment. But how could he mix his early Greek education, his Middle-European culture picked up in Munich and his French intellectualism (which so fascinated Apollinaire and later Cocteau) with the eternal mystery of Zarathustra? The answer was simple. There was an enigmatic and disquieting world waiting to be discovered at every street corner. One only had to know it was there in order to see it.

Each one of us lives day and night with his own madness or his own wisdom, as Nietzsche had found out. And it was not by chance that de Chirico looked for his spiritual forebears among the philosophers of the negative (Schopenhauer, Weininger) and among the German Romantic painters (Böcklin, Klinger), because the whole of his activity was mental and visionary. His 'Piazzas of Italy' are really enquiries into psychical disorientation; the opening and closing of doors in the conscious and unconscious; the invention of a Renaissance that never was. Resembling the Parthenon, each of his railway stations becomes a temple to the goddess Departure. His mannequins are the modern equivalent of the statue, which always interested de Chirico as a cast (and by extension, as a double, a reflection, a shadow). His horses, his furniture in the valley, his trophies and gladiators all represent the retrieval of memory and so have little to do with the dreams and nightmares of the Surrealists.

Yet, with all this store of myths, de Chirico is not a descendant of Freud (although he was among the first to quote him in Italy) but another original and authentic contributor to the science of the soul. The mystery of time, the x-raying of the unconscious, the enigmatic presentation of the enigma, these have tended to mislead analysts of his work and should not be given undue weight. The facts that de Chirico expounds on page and canvas are in reality very few and all go back to his (mythical) personality. More than anything it is his clairvoyance that strikes the mysterious spark which we call art.

Another way into his cosmos (tortuous by reason of the cunningly multiplied enigmas) can be found by viewing in chronological order his self-portraits culminating in what he has to say in his memoirs. What we see is the self-portrait used as the mirror of Narcissus, creating the image of the superman, providing a sublime disguise. One of Nietzsche's commandments was to 'want everything that has ever happened'. And what else is de Chirico doing when he gets himself up as a melancholic or as Böcklin or as a Spanish grandee or Euripides, or changes himself into a statue, or when he depicts himself with his shadow (anima, ka), or when he turns before our eyes into an oracle or an 'Ecce Homo' or Odysseus or Apelles?

In his one hundred self-portraits, de Chirico has always some association to reveal. He is never on his own but always *with* somebody (with Hermes, with his mother or his learned brother, with his muse, with Euripides...). Moreover he is never in an ordinary pose, but always playing a part (someone 'born under the influence of Saturn', or Raphael, or a Renaissance gentleman, or a Baroque figure, or an eternal statue...). It is really in his self-portraits that the Metaphysical can be seen at its most intense. There is nothing more *physical* than a portrait, but each time de Chirico paints his portrait his vision takes it *beyond* the physical. His revered Weininger (the philosopher who killed himself for a bet) can clarify the artist's intentions in assuming so many guises. The number of different faces that appear in succession on a man in the course of his life, Weininger wrote, can be considered a true physiognomical measure of the greatness and rarity of the gifts he has received. From this it is only a small step to conclude that, for all the imagination expended over the years in identifying with everyone, Giorgio de Chirico ended up identifying – enigmatically – only with himself.

Pictor Classicus Sum: Giorgio de Chirico, Integrity and Reaction

At the age of thirty-two, when both his intelligence and his sensibility led him to re-examine from a cautious distance his own early success, de Chirico, in an essay on his beloved Arnold Böcklin, discussed the problem of misunderstanding[1].

There are artists whose greatness unfortunately rests on misunderstandings formed during and after the time in which they were working. Misunderstandings which arose because foolish and narrow admirers of their art interpreted it falsely. Men with a special reputation for intelligence, men with the instincts of old foxes who are not easily caught, withdraw to a distance and observe with suspicion those who are afflicted with this sort of praise: the platitudes based on ignorance; the tone of the praise; above all the category of person doing the praising! . . .

As so often in de Chirico's commentaries on art, there is a prophetic relevance to later developments in the 20th century – in this case to the incredibly distorted view of his own work still held by many otherwise not insensible people. Society's censorship of its artists, poets and philosophers has a long history but it is a vice peculiar to our own age to let this censorship take the patronising form of publishing a partial and fragmentary version of an artist's work and intentions – and then to praise it mightily for largely irrelevant reasons.

In de Chirico's case there is a widespread and continued acceptance of a facile misconception, that for ten years he produced 'avant-garde' masterpieces and then relapsed into uninspired academicism. This judgement of the 'late' paintings as worthless pastiches of his own or other artists' work has perhaps more than a little to do with the rarity with which the original works are seen. It is sometimes overlooked that he was busy painting those 'late' works from 1920 until his death almost sixty years later.

To attempt a comprehensive explanation of this blindness to de Chirico's achievements would require an analysis not only of the history of art and art criticism of the last hundred years, but also of the development of the art market. De Chirico has himself engaged in this with great wit and perception in his polemical writing. We will be content here with suggesting that one should look at his entire output as the unity it is, and try to see through the misconceptions with which it has been surrounded.

Dreamlike, silent, lonely, timeless, melancholic, mysterious – this list of clichés seems to have an irresistible fascination for critics and historians in their attempts to describe the paintings made before 1918. More seriously, they have effectively prevented each new generation from seeing the paintings as they are. De Chirico himself, of course, sometimes used such adjectives in titling his works but they are of no more and no less significance to a real understanding and enjoyment of the pictures than would be a descriptive list of the subject matter used – arcades, statues, railway trains and biscuits.

One of the causes of this superficial approach lies in the persistence of a romantic fable, the definitive version of which was invented by the Surrealist movement in the third decade of this century, concerning the way in which art is made. According to this fable, paintings are the result of some mysterious, unconscious process of forming visions in the head, which are then transferred spontaneously as an image on to canvas, the whole being powered by the force of genius. If genius flags, there is a loss of inspiration – a fault of which de Chirico is not the only major painter of this century to be accused. It is usually said to occur when there is a change in the artist's aims, subjects or techniques – in other words when it upsets the preconceptions or expectations of the dealer, collector, commentator or curator. In de Chirico's case it would perhaps be more useful to discard such theories and to look at what and how he painted, and to read what he wrote about his intentions. This is not to ignore the certainty that the great originality and depth of the works painted by de Chirico after 1910 were partly the result of one of those inexplicable jumps in perception and sensibility with which the imaginations of great artists are sometimes blessed. But it is equally certain that a mind capable of making such a jump would not rest content with turning its new insight into a style.

In the 1970 interview *I Have Always Painted as I Wished*[2], de Chirico states:

In my work there are no stages, no transitions from one style to another, as has sometimes been maintained. I have always painted in that way which gave me pleasure. I have always practised realistic painting, for example painting of quality, since 1918, for more than fifty years, quite right, that kind of painting which our modernists call baroque in the defamatory sense of the word or, worse still, baroque-like ornateness. What does that mean? All painting since the mediaeval masters is baroque. One cannot paint like Giotto any more. Anyone who tries just wants to furnish himself with a style.

Perhaps he cannot do anything else. In my painting, by contrast, there is an intensification of quality. I continually try, in a qualitative sense, to make them better . . . It is irrelevant to distinguish a de Chirico of yesterday from one of today. There are neither good nor bad de Chiricos. Metaphysical painting is of the spirit, it is an invention, while the realistic is an art of quality, which demands extraordinary intelligence. Painterly intelligence is of a special kind. I mean that a person can be intelligent without understanding a thing about painting. The reverse is also true. Luckily I have the gift of both sorts of intelligence, the metaphysical, which means the one for imagination and poetry, and the other, for quality in painting. Quality in painting, however, always contains a metaphysical element. It is not granted to everyone to paint pictures of high quality. With that the imagination comes into play again. Realistic means this: that the theme of the picture is tied to reality. But realism is not to be produced without quality.

After the age of eighty, de Chirico's style of writing was sometimes oblique, often patriarchal in its arrogance, but in that statement we are given one of

the clearest indications of the two aspects of painting with which he had concerned himself throughout his life – the 'Metaphysical' and the 'Realistic'. To both of these terms he attached special and not always fixed meanings. His use of the term 'quality' in connection with painting may be related to the 18th-century use of that word to describe people. It refers to something 'fine', 'good', 'cultivated', but depends for its understanding, ultimately, on a consensus about how those attributes are to be recognised and on an acceptance that such characteristics of good breeding are really laudable or even relevant.

The famous account given by de Chirico of how in 1919 in the Villa Borghese he first came to realise what 'quality' in painting meant[3], is often read with too much emphasis given to the allegorical description of tongues of fire appearing in the gallery and triumphs resounding in the street. He goes on to distinguish between experiencing painting as a thing in itself and seeing it merely as a painted image. He stresses that this realisation was only a beginning for him, to be followed by years of study, work, observation and meditation. The 'painted image' is of course the subject of the work – something which de Chirico always placed in a subservient role to quality.

The metaphysical, described as coming from the realism of poetry and the imagination, has less to do with painting as a procedure. It is a way of looking at, or through, the subject or the finished canvas. It is the desire for a further reality beyond appearances, the grasping after what de Chirico calls the 'second aspect of things'. This desire has been, since the Classical age in Greece, the mainspring of Western art, which has caused artists to look repeatedly at nature, their predecessors and their imaginations. It has nothing to do with superficialities of mood, subject or style. The use of the word 'metaphysical' to denote a certain phase of de Chirico's work in much the same way that 'synthetic cubism' is applied to a period of Picasso's work, is a tragic debasement of language.

De Chirico always took care not to define the metaphysical in painting but rather to hint at a description of it. And those descriptions always included a reference to that complementary aspect of his work, the realistic. In an essay of 1924 on Gustave Courbet he writes:

In those times fantasy, that gift of God which cannot be separated from talent, had an effect on the work of art. Some imagine it to be the ability to picture what has never been seen. The painter, and the artist in general, needs fantasy less to imagine the unexperienced than to transform the seen. Let us not misunderstand the sense of the term 'transform'. 'Transforming' can be the dissolution of the normally represented world into banalities . . . Fantasy is not limited to pictorial devices. Like a light which shines out here and there from the pure spirit fantasy, spreading through the picture, illuminates the colours, ennobles the material and brings fire and grace to the finest details of the technique. Fantasy is the

first condition for the happiness of the artist . . . Courbet is the painter of the 19th century who had best heard and repeated the secret song of his time . . . Courbet is a romantic and at the same time a realist. The more a person has developed the abilities of poetry and the imagination, the deeper is his sense of reality. Böcklin was the greatest poet among painters there has ever been, and he was also an extraordinary realist . . . For the true artist, realism means the possibility of expressing precisely what he feels and imagines . . .[4].

These writings of de Chirico in the early 'twenties, the result of a passionate and intelligent love of paintings and painting, formed the basis, – which was to underlie all of his work as a mature artist – the commitment to the classical. *Pictor classicus sum*, the motto he had already chosen for himself in 1919[5], had to do neither with a style nor a historical period but with a belief in the moral and practical lessons which must be learned from the past by anyone claiming the title of painter. In 1945, after the liberation of Rome, describing the situation of the arts twenty years earlier, he wrote:

Never, since the beginning of the world, since men have exerted themselves drawing, painting, modelling and sculpting, never, I say, have the highest values of the spirit and the highest aspirations of mankind, namely art and works of art, reached such a state and in this way been prostituted and dragged through the mud. There are two great scandals of our time: the encouragement given to what is bad in art and the fact that there is no opposition to this encouragement by any authority, either civil or ecclesiastical. At the same time there is speculation based on deceit even on swindling, which takes advantage of the ignorance, vanity and stupidity of the men of today. All this had and still has one sole purpose, one sole motivation: money – to earn money at all costs, to earn it in any way, under the aegis of a false artistic ideal[6].

Those conditions described by de Chirico as prevailing in 1925 (and he was not to find much improvement during the rest of his lifetime) were hardly conducive to the production of a classical art. The classical demands security and stability, not of political or economic conditions, but of thought and ethics. In the corrupt and degenerate age in which he found himself de Chirico saw himself as a man with a mission to fulfil. This mission, the preservation, or rather restoration of the dignity of painting, the re-establishment of a respect and love for the old masters

1. *Arnold Böcklin* in *Il Convegno*, Milan, 1920, 4 pp.47-53. translated into German by Anton Henze in *Giorgio de Chirico, Wir Metaphysiker, Gesammelte Schriften* edited by Wieland Schmied, Propyläen Verlag, Berlin, 1973.
2. Excerpts from an interview with de Chirico in *L'Europeo* Milan, 30 April, 1970, pp.36-42. (*Wir Metaphysiker* p.183)
3. *The Memoirs of Giorgio de Chirico*, 1962, translated from the Italian into English by Margaret Crosland, Peter Owen, London, 1971.
4. *Courbet, Rivista di Firenze*, Florence, November 1924, No. 7 (*Wir Metaphysiker*, pp.119-121)
5. *Il Ritorno al Mestiere*. Valori Plastici, Rome, November 1919, No.11-12 (*Wir Metaphysiker*, p.56)
6. *The Memoirs of Giorgio de Chirico*, p.116

and the values they represent, went parallel with what he saw as the duties of the civilised man towards our culture in general.

In his memoirs, he has given a description of his father:

My father was a man of the nineteenth century; he was an engineer and also a gentleman of olden times, courageous, loyal, hard-working, intelligent and good. He had studied in Florence and Turin, and he was the only one of a large family of gentry who had wanted to work. Like many men of the nineteenth century he had various capacities and virtues: he was a very good engineer, had very fine handwriting, he drew, had a good ear for music, had gifts of observation and irony, hated injustice, loved animals, treated the rich and powerful in a lofty manner, and was always ready to protect and help the poor. He was also an excellent horseman and had fought some duels with pistols; my mother preserved a pistol bullet, set in gold, which had been extracted from my father's right thigh after one of his duels[7].

In his attitude to painting, de Chirico shares some of those gentlemanly qualities of correctness, goodness and courage which his father had exhibited in his life. In spite of his contempt for war, de Chirico was an admirer of the military virtues, and often in his writing he uses metaphors and similes from that ancient human activity. The characters and themes which so often recur in the works from 1920 onwards – the warriors, gladiators, horsemen and heroes – perhaps mark a change in the paintings from the metaphysical to the realistic, from introversion to a concern with the external world. For a mind as speculatively profound as de Chirico's, and given the vast range and complexity of the task he had taken on, this change could be neither a simple nor a quick one.

At the beginning of his career he had painted works such as the 1909 *Battle of the Centaurs* – a technical homage to Arnold Böcklin as well as evidence that he had already understood that master's use of poetic parable and irony to describe reality. Irony, indeed, is the indispensable crutch of the classical spirit in ages where it no longer finds any other support. The late paintings of Jacques-Louis David, full of, to the trained, blinkered eye, naive sentimentalities of subject, and an embarrassing directness of expression, are the conscious, subtle matching of his own vast experience with a new and debased era. He adapts his method, while retaining his integrity, and interprets the world about him without either squeezing it into the mould of a bygone time or vainly embracing the chimaeric models of fashion.

De Chirico's irony, irony in the original Greek sense of ignorance purposely affected, had existed from the start, although his sense of humour, as with many people of intelligence, was to develop only after his phase of youthful introspection was ended. Irony, humour, hyperbole and understatement are all devices used continuously by de Chirico in his writings and paintings[8]. A large part of the misconceptions about him may be ascribed to a neglect of this fact by a

Portrait in 17th-Century Costume
1953

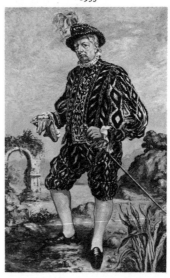

rather solemn phalanx of intellectuals and students, busy with Freudian interpretations of Surrealist theories and looking for a rational progression in the development of artists. After 1920 he continued to expand the categories of subject matter and the kinds of expression in his work, as well as investigating a great variety of technical mediums and materials, and of ways of using them as descriptive language. This was parallel to his studies of the old masters and his reflections about the subject matter and aims of painting. The almost metaphysical inscrutability of the detailed technical descriptions given in his writings will surprise only those students who are unfamiliar with the reports of other great authorities on this subject.

Technique, used in its widest sense to include drawing, composition, the control of the paint and its mediums, the choice and the mixing of the colours, and the way in which all these relate to a particular image, technique in this sense is inseparable from de Chirico's broader aims and intentions. It is also inextricably bound up with criticism of those aims by an audience with a pre-conceived idea of what paintings today should or should not look like. To clarify this, we should now turn to look at some of the paintings themselves[9].

In the 1953 *Self Portrait in 17th-Century Costume* de Chirico displays himself in a double disguise – the artist dressed up in the period costume of another century, and the painter adopting the role of the sitter. But the sitter in this case has the attitude and character of de Chirico – looking the contemporary spectator

7. *The Memoirs of Giorgio de Chirico*, p.15
8. See particularly: *Hebdomeros – a novel* by Giorgio de Chirico, first published 1929; translated from the French by Margaret Crosland, Peter Owen, London, 1968.
9. Titles and dates for the works mentioned are taken from *de Chirico* by Isabella Far, Fratelli Fabbri, Milan, 1968. English edition Harry Abrams, New York, 1968.
10. *The Memoirs of Giorgio de Chirico*, p.231.

Angelica and Ruggero
1954

sternly and ironically in the eye, and holding the gauntlet ready to throw down. The picture is composed with a subtle rigour worthy of the 17th century masters he is quoting. The notion of representation uses a convention akin to that of Rubens, which permits of a marvellous mixture of observation and invention. The red used to indicate the deepest shadows is echoed in the local reds of the background, the blue of the sky repeated in the perspective blue of the distant hills. An almost unnoticeable break in this convention occurs in the use of a black outline round the legs, and certain other parts of the painting.

This deliberate separation and juxtaposition of drawing and colour is found often in de Chirico. In his notes on technique he describes the use of oleo-resin varnishes to allow the superimposition of brushstrokes without the second disturbing the first, even in the wet-in-wet method[10]. This can be seen very clearly in the paintings of the forties and fifties, a period when he was particularly concerned with perfecting a great variety of technical procedures – the results of his studies of old recipes, as well as practical experiments. In the *Fruit in a Landscape* of 1944, the brushstrokes can be counted almost singly, so clearly are they defined, but at a distance they add up to a surface which looks as if it would feel like an apple to the touch. There is an overpowering sensation of substantiality, of reality, in this still life set in a painted landscape. In the *Portrait of a Young Italian Woman* of 1948, the homogeneous pictorial language has a confidence and perfection which comes from its complete integration with the subject. To the viewer, the sitter is presented with the surprise and directness of an unexpected bump into an old friend turning the corner in a strange city.

A more complex use of language can be seen in *Angelica and Ruggero* of 1954, an example of the 'set piece' to which de Chirico often turned as a test and stimulation for his imaginative and technical powers. The 1950 picture uses a single notation to describe a

nude studied from the life and a putto taken from the 17th century. A recognisably 1940s hair style around a contemporary face turns into a demonstration of the technique of painting hair with the method of tempera and oil glazes. The anatomy, realistic without any trace of naturalism, achieves a monumentality through the use of single brushstrokes to re-establish the picture plane contiguous to the surface modelling within the outline. An earlier use of this device can be seen in the 1924 *Return of the Prodigal Son*.

Angelica and Ruggero uses an unusual visual conception. The model, painted from life with an almost pedantically direct technique, stands before an artificial arrangement of velvet drapes and rocks, more concerned with her role as an actress than with the heroic actions of Ruggero. Just as in earlier paintings de Chirico was able to make the spectator aware of something special and profound by exploring the relationships of figures and objects to one another in an environment where time and space were no longer subservient to causal laws, or common sense, so here he achieves a similar result by manipulating the relationship of theatre and mythology. The starting point is not our perception of the world, but our understanding of culture, and the motives which produced the early 'metaphysical paintings' have changed not their aim, but only their point of application.

A quite different use of mythology is to be seen in *The Guardian of Thermopylae* of 1966. The substantiality of things has been removed, but in a schematic form all the elements of the painter's basic vocabulary remain: outline, modelling, local and reflected colour, chiaroscuro, as well as the qualities suggested by those elements – light, scale and space, and of course the representations of real things – a mountain pass, a table with folded red cloth, and the shadow of Leonidas. From the same year is the *Sunlight on an Easel,* where the electric symbol, hovering between an ancient sign for the god Mazda and a modern strip cartoon, is part of a deliberate, outrageous understatement on de Chirico's part, just as the mighty *Still Life with Silverware* of four years earlier is a demonstration of virtuosity in the handling of an arrangement of baroque sumptuosity.

Still Life with Silverware 1962

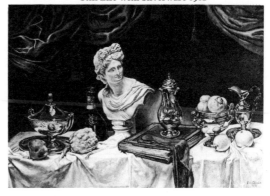

The Guardian of Thermopylae
1966

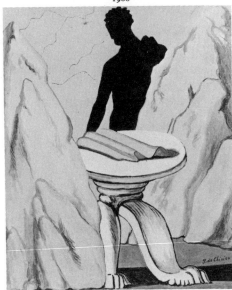

Sunlight on an Easel
1966

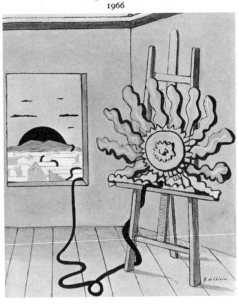

Earlier parallels to these two approaches can be found in *The Fatal Temple* of 1913, and the *Ulysses* of 1922. In the first painting, diagrammatic and literary elements are used evocatively. There is a youthful confidence in the efficacy of poetry, a belief that the painter can directly seize the intangible. With the *Ulysses* the problems and ambitions of the maturer artist are sensed in the near awkwardness of the proportions, as well as in the choice of subject. Facility has been rejected with the decision to leave Calypso, but the poetry has deepened. The figure of Ulysses points back to Böcklin and forward to the Andromeda of forty years later.

A subject, or technique, may be chosen because it fits the intentions or the desire of the artist, because it promises to stimulate and educate his imagination or, for tactical reasons, because it should affect the eyes or minds of his audience in a particular way. With de Chirico, any or all of these motives may underlie a particular work. His ambition was to encompass everything with painting, to deal with a description of the most ordinary apple and to evoke the most fleeting of sensations, or the most profound insights; at the same time to investigate every possibility within the art of painting – its materials, its rules, its disciplines and its pleasures. This programme was carried out in virtual isolation, in opposition to an establishment attitude to art which even claimed his own early work as part of its justification, and it was carried out with unfailing courage and integrity over a period of sixty years. We may look to his example of determination and strength, not as the fashionable hero on the side of 'progress', not as the facile destroyer of convention, but as the lonely guardian of those values which are the sole means of rescuing, rather than exterminating our civilisation.

To close, let us look at his 1945 poem, *The Morning Prayer of the True Painter*[11]:

My God, make my craft as a painter
More and more perfect.
Let it be, my God, that with the help
of materials
I will achieve greater progress
Until the last day of my life
Give me also, my God, intelligence
More strength, health and willpower
So that I may always improve
My emulsions and my daubing oils.
So that they will help me
more and more,
So that they will contribute
to the substance of my painting,
And to greater transparency
and body,
To increasing polish and fluidity.
My God, stand by me,
Above all inspire me,
So that in my work as a painter
I solve the problems of the materials.
So that I can restore the splendour
of painting.
The splendour it has lost
for almost a century.
Help me, my God, to re-establish
the honour of painting,
In that I solve the problems
of the materials.
For the metaphysical
and spiritual problems,
They are now solved by the critics
And the intellectuals.
Amen.

11. *Preghiera del Mattino del Vero Pittore 1945*, from the catalogue of *Giorgio de Chirico*, Milan, 1970. Edizioni del Ente Manifestazione Milanesi 1970. (*Wir Metaphysiker*, p. 159).

Wieland Schmied
Unity and Variety in the Work of Giorgio de Chirico:
A Personal Memoir

Giorgio de Chirico
in his studio in Rome,
1976

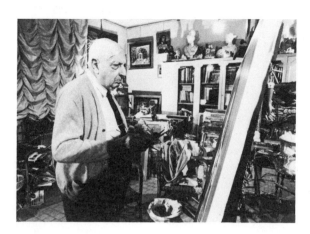

Very few of the great artists of this century have as many differing, even contradictory facets to their work as Giorgio de Chirico. We may quote many different qualities in his praise save one: continuity. Until the very last phase of his artistic life the dominant feature of his work was change. The divide between the paintings of his early Metaphysical period before 1919 and those of the following neo-classical phase alone is so deep that we have to ask ourselves: Is this the same painter who created them? What were the changes which obviously influenced his whole personality structure? What were their causes?

These questions impressed themselves upon me when I first met Giorgio de Chirico, and they still preoccupy me today. It was in September 1968. At that time I was preparing – in collaboration with the Palazzo Reale in Milan, which had also appointed me to their committee – the first great retrospective of the artist, which I wanted to show at the Kestner-Gesellschaft in Hanover in 1970. This gave me the welcome opportunity to meet the painter personally – even though some of the Milanese committee members thought it unnecessary as we could equally well make our selection without contacting the pugnacious maestro and his wife.

I met Giorgio de Chirico in his flat at the Piazza di Spagna; a carefully and expensively furnished flat with Persian carpets and period furniture, which made me feel a little overawed. Everything appeared to be in velvet and plush with glittering silver and crystal chandeliers. On the walls, in heavy gilt frames, the neo-Baroque paintings of the '40s and '50s. (He himself didn't like the expression 'neo-Baroque', as I was soon to find out.)

For someone who was only really familiar with his metaphysical paintings and who only knew the later ones from hearsay rather than from personal experience, the sudden confrontation with the neo-Baroque style, which seemed to be so totally out of tune with our modern world, turned out to be quite a big shock. To whom had I come?

The eighty-year-old greated me with formal friendliness – or rather should I say: composed dignity? He spoke fluent German – he had already learnt it in Athens before his three-year stay in Munich from 1906–1909, where he studied at the Academy of Fine Arts, discovered Böcklin and Klinger for himself, and read Schopenhauer, Nietzsche and Weininger.

I had come to Rome via Turin. This gave us the chance to speak about this town, whose architecture, palazzi and arcades had impressed him so deeply, and which had shaped the vision of his Piazza d'Italia so lastingly. He told me that for him Turin had always been the city of Nietzsche. And he quoted by heart poems by Nietzsche from *Prinz Vogelfrei* and passages from *Zarathustra*.

He by no means renounced his metaphysical period, but he wanted to be acknowledged for all his works, and having been brought close to anger by previous attacks, he emphatically insisted on this point. We fully respected that wish in the exhibition that was organised for Milan and Hanover. There were disagreements about the inclusion of certain paintings, owing to the importance attached to different periods of his work (de Chirico was particularly fond of the later ones) but an amicable solution was always arrived at.

'In my early paintings I tried to express ideas', de Chirico said. 'Later I was exclusively concerned with the quality of painting.' And then, simplifying greatly: 'I have always painted metaphysical and physical, in other words realistic paintings as I felt like it. That's all.'

The big surprise of the evening, however, was still to come. One floor above the salon was the studio. Here I saw for the first time those 'neo-Metaphysical' paintings that he had started to paint in the '60s – free, often bizarre and thought-provoking variations of the earlier imagery, with many new themes. These, too, had a strange effect on me initially – until I realised how they began to fascinate me more and more strongly on each further visit. I shall never forget *The Return of Ulysses* which I saw there, standing on the easel.

Until the death of the artist in the autumn of 1978, I returned to his flat often several times a year, encouraged not least by the constant warmth of Signora Isabella de Chirico. Soon I began to feel at home at the Piazza di Spagna. And I learnt to see the later phases of de Chirico's art with different eyes, by trying to place myself within the intellectual and emotional world of the artist.

These later phases included the following idioms: the period of the 'neo-classical' paintings in Rome 1919–25, when he established the creed *Pictor Classicus Sum* and painted the 'Roman Villas' and the 'stony' self-portraits; the second Paris period with the recurrence of the mannequins and the creation of a new mythology – the archaeologists and gladiators, the *Furniture in the Valley,* the *Temples and Rocks in the Living-Room,* and the *Wild Horses at the Beach,* which always turned out to be the beach of his native Thessaly...

It further comprised the renewed creed of Realism about 1930, with studio and landscape pictures; the return to mythology with the *Mysterious Baths* and the *Phrygian Riders* in the middle of the '30s, and lastly – we'll omit several intermezzi, leave out the stage set designs for La Scala in Milan and the Maggio Musicale Fiorentina – the turn to Rubens and Baroque imagery, which had captured his love from the '30s onwards.

And all this was the work of just one man? What kind of a man that had to be! And how many things must have happened inside his mind!

At that time I started to reflect about de Chirico and I still haven't reached a conclusion. By getting to know some of the details a lot of things gradually became clearer – but in the end he has always remained deeply enigmatic and impenetrable for me.

I tried to get hold of all kinds of documents which might help me in any way to decipher this mystery – and sometimes, like a detective putting together the parts of a jig-saw puzzle, I thought I was able to reconstruct and grasp a certain part of his life – but then he would slip away again.

This much at least I understood: de Chirico saw his own life as a unity, however rich it might have been in its varying facets. The resistance of a world, and the opposition of the public, which he had experienced all his life, had an effect like a clamp, holding his life together from the outside.

Indeed, he didn't see any irreconcilable opposites in his work, even if in his writing he occasionally reflected on the right of the artist to change his position. Only this feeling of a unity empowered him and rendered it possible to take up and vary certain motifs and themes again and again (not only from the Metaphysical period but also the Roman rocks, the Parisian city views, the archaeologists and gladiators, the Thessalian beaches and horses, the mysterious baths...).

During his last years, when a lot of his ideas had hardened and, tired of stereotype questions, he reacted more brusquely than before, and said: 'I have never changed'. There was no further discussion on this point.

When I thought about several of the basic impulses and basic attitudes of his life, the romantic ideals to which he had remained faithful over the years, the decay of values, which he continually deplored, the concept of immortality, which had always occupied his thoughts – then I was inclined to agree with him and to accept his own assessment of himself. But then I had doubts again.

And that's how it has remained until today. Sometimes I can see the picture of the one, homogeneous de Chirico convincingly clear in front of my inner eye – but then it crumbles again into many contradicting single pictures. But even if all these single pictures could not be united again – I would not want to be without a single one of them.

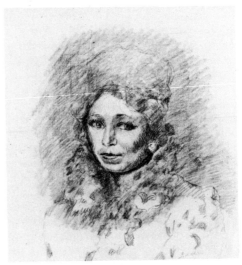

Portrait of Isa *c.* 1940
drawing

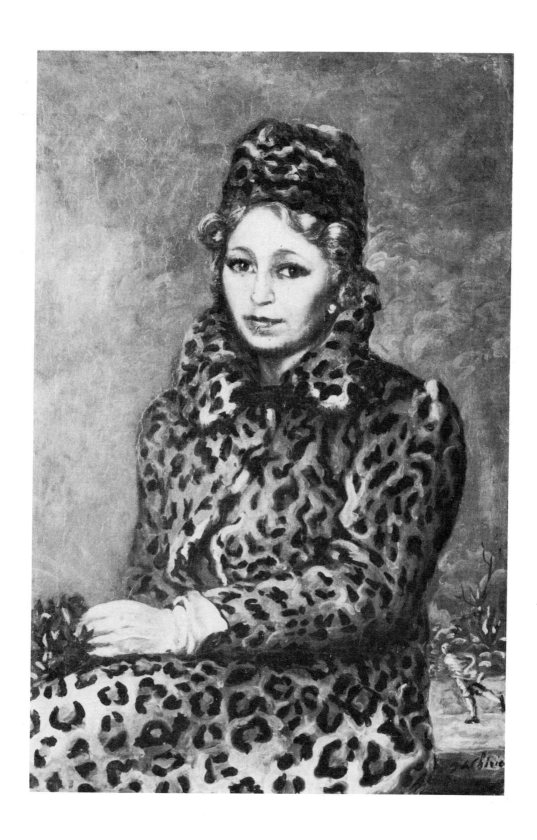

The Leopard Skin Coat (Portrait of Isa)
1940

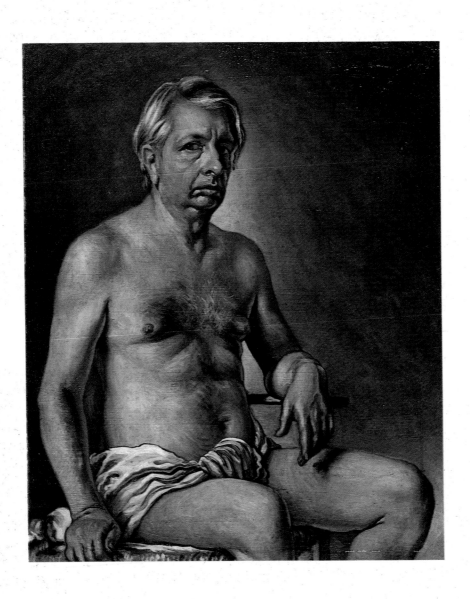

Nude Self-Portrait
1945

Gladiators inside the Room
1953

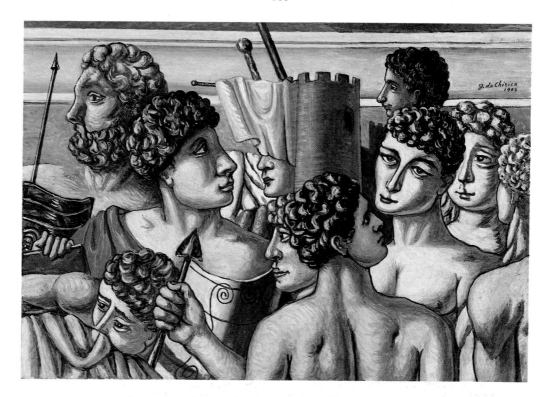

Achilles at the Spring 1946

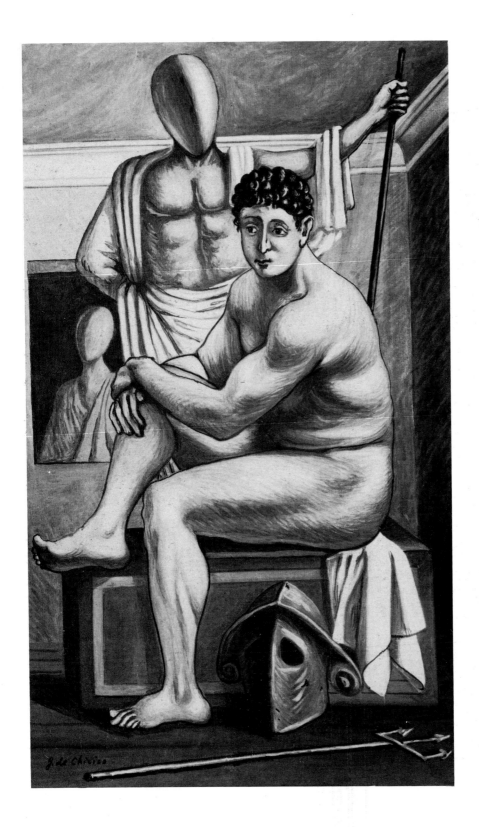

Tired Gladiator
1968

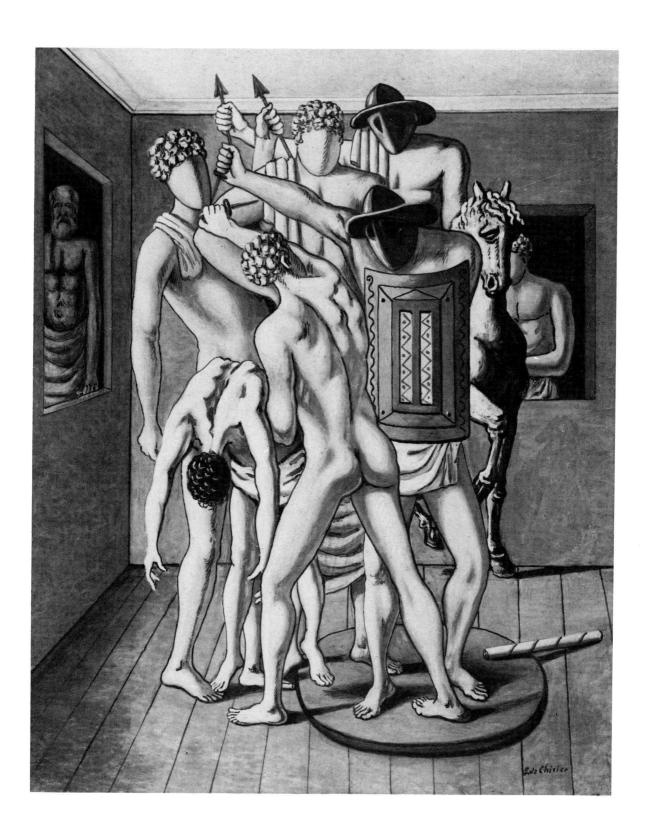

Gladiators inside the Room
1953

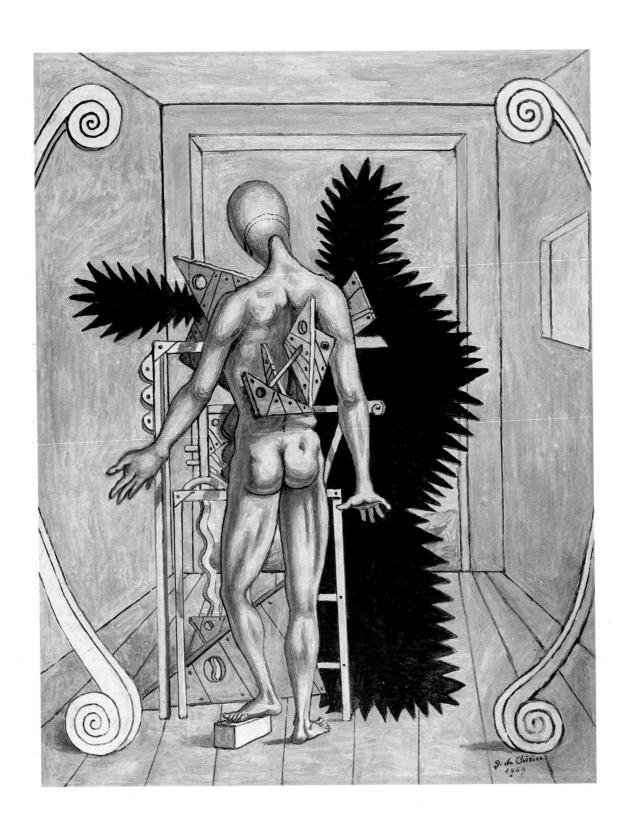

The Remorse of Orestes
1969

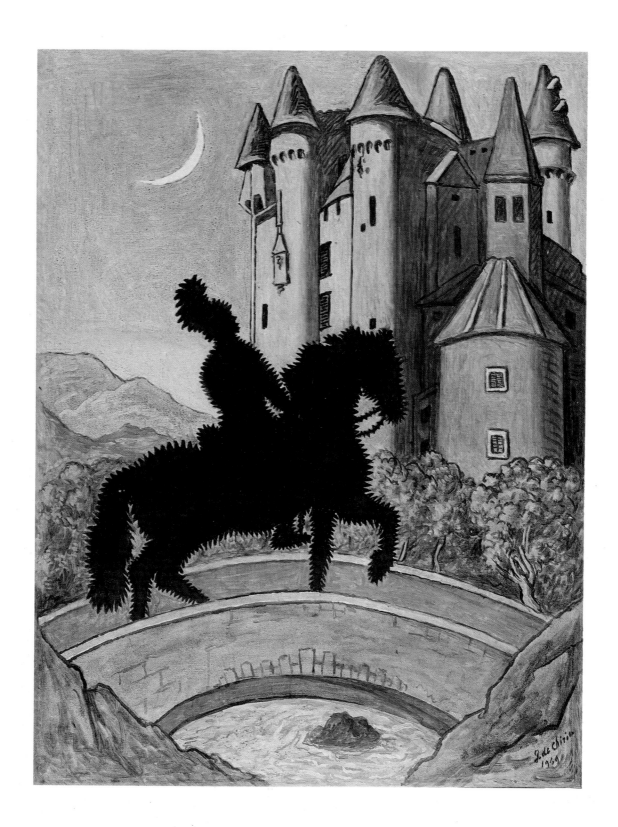

The Return to the Castle
1969

Mysterious Baths with a Swan 1958

Hector and Andromache before Troy 1968

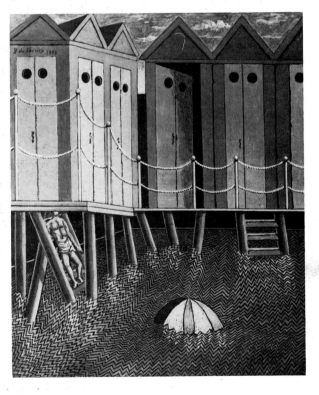

The Muse 1944

Mysterious Cabins 1956

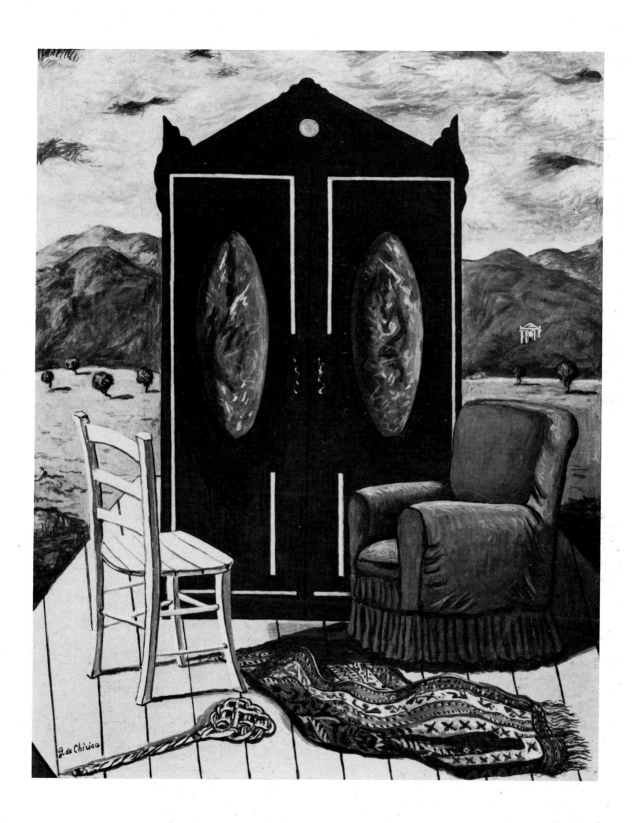

Furniture and Carpet in the Valley
1968

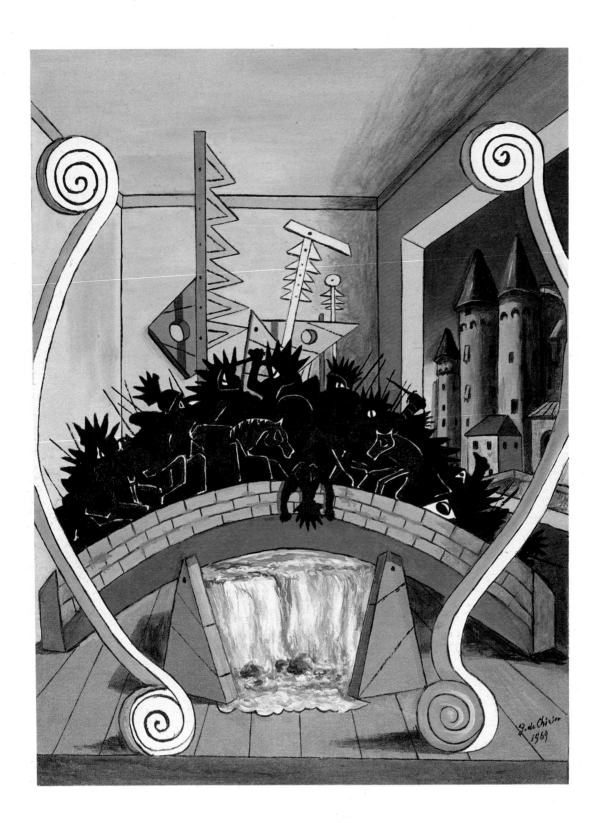

Battle on the Bridge
1969

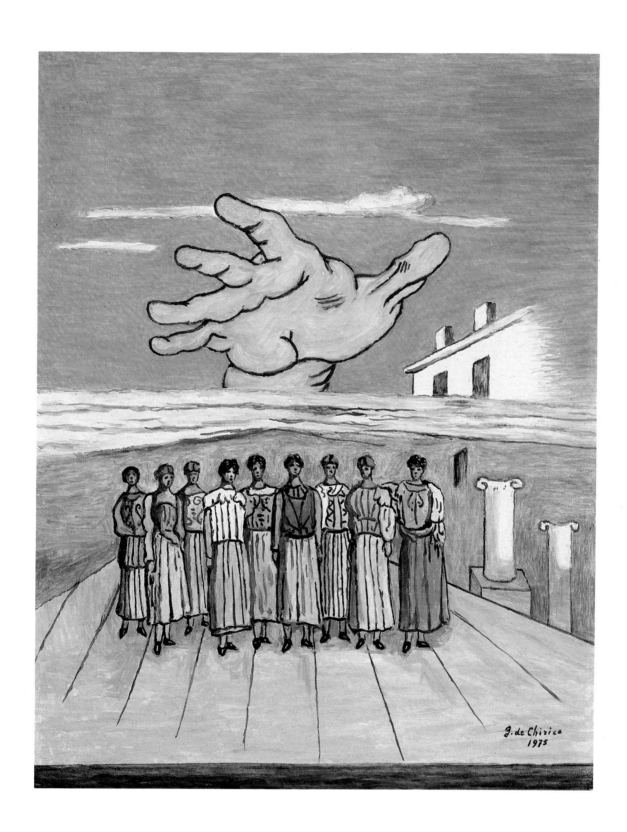

The Hand of Zeus and the Nine Muses
1975

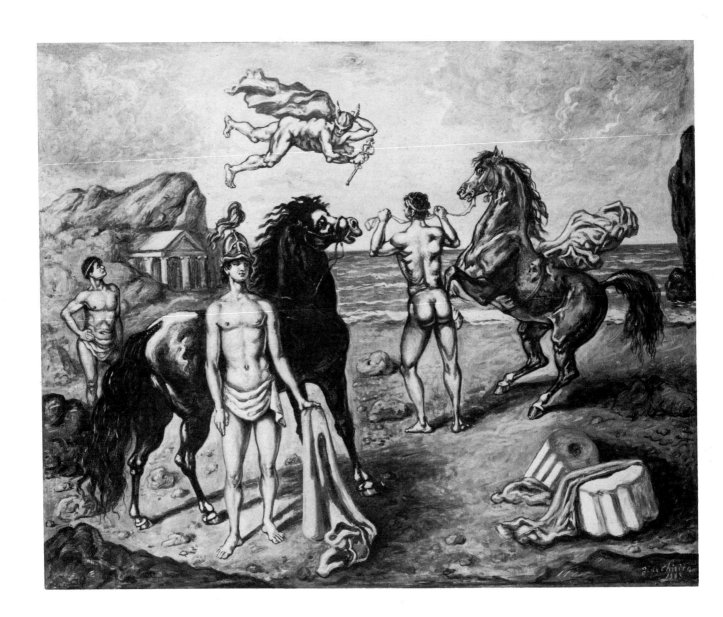

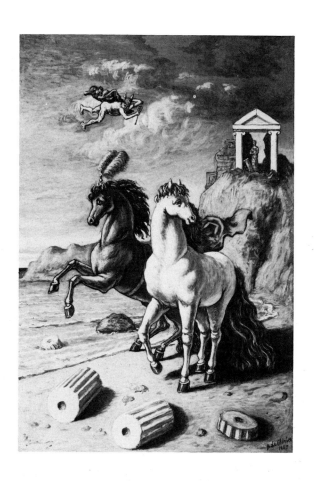

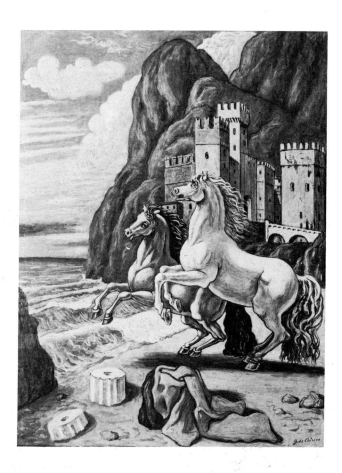

Horses with the God Mercury
1965

Ancient Horses at the Foot of a Castle
1968

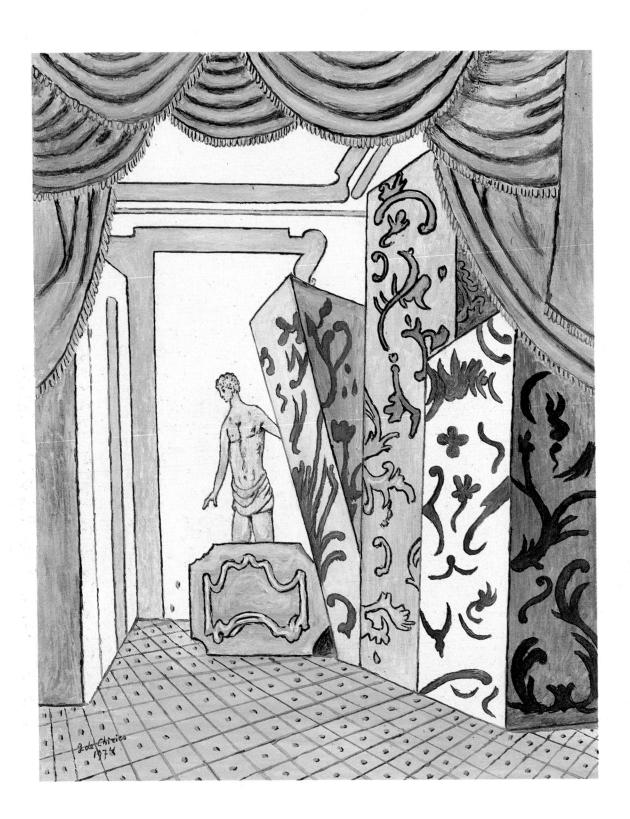

Mystery of a Hotel Room in Venice
1974

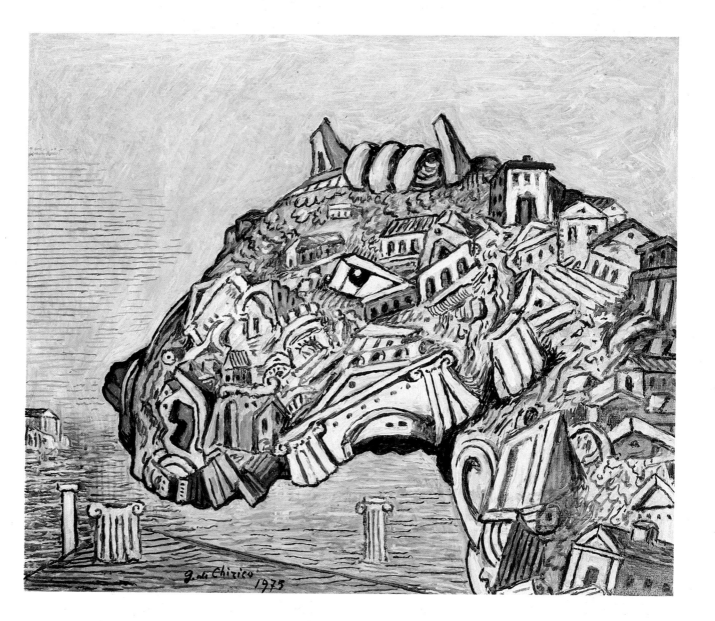

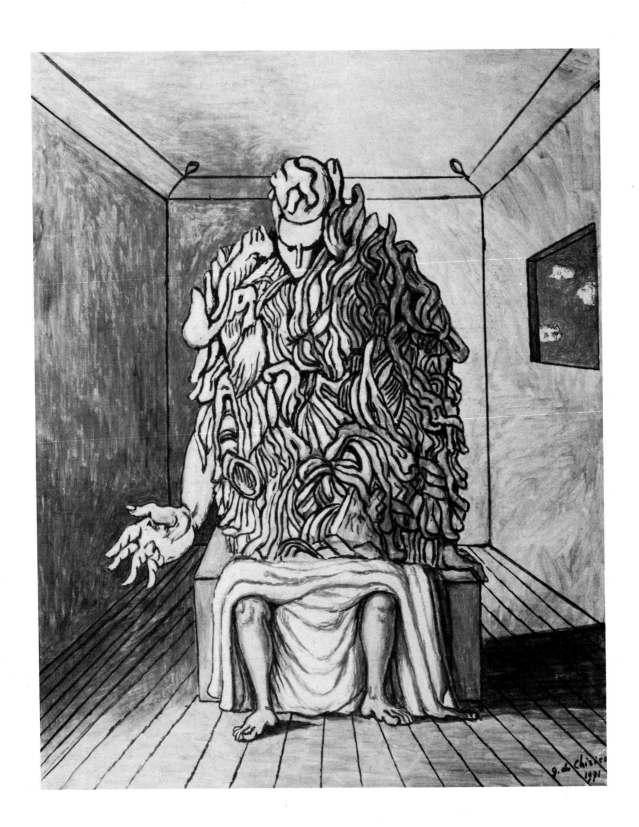

The Thinker
1971

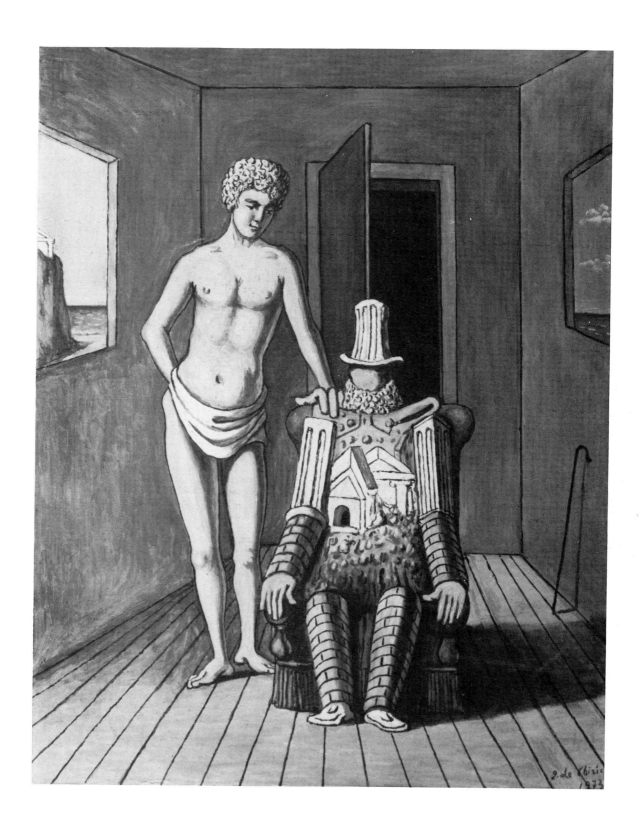

The Prodigal Son
1973

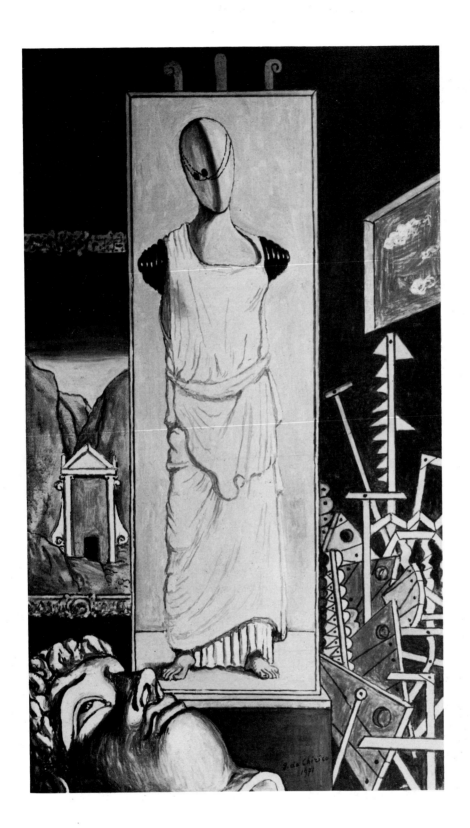

The Secret of the Bride
1971

The Great Game (Piazza d'Italia) 1971

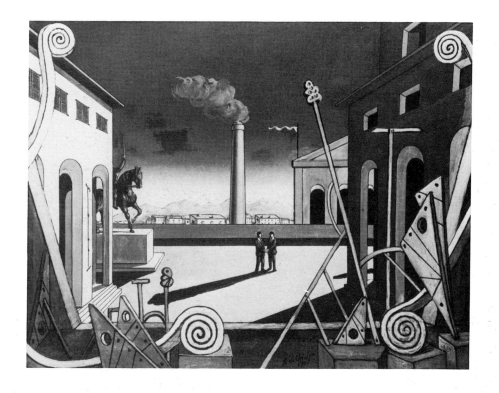

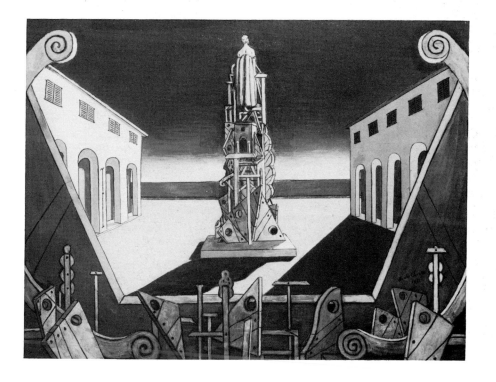

Great Metaphysician with Squares
1971

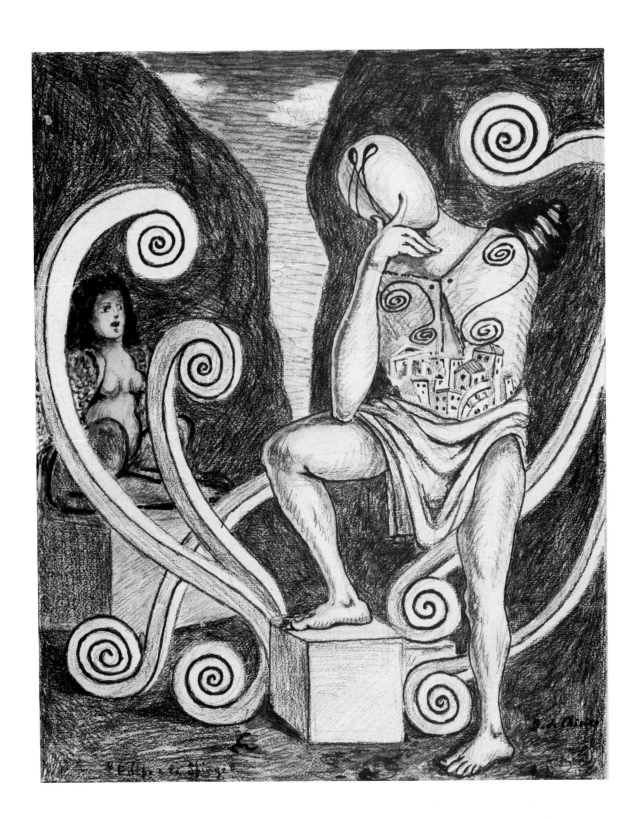

Oedipus and the Sphinx
1969

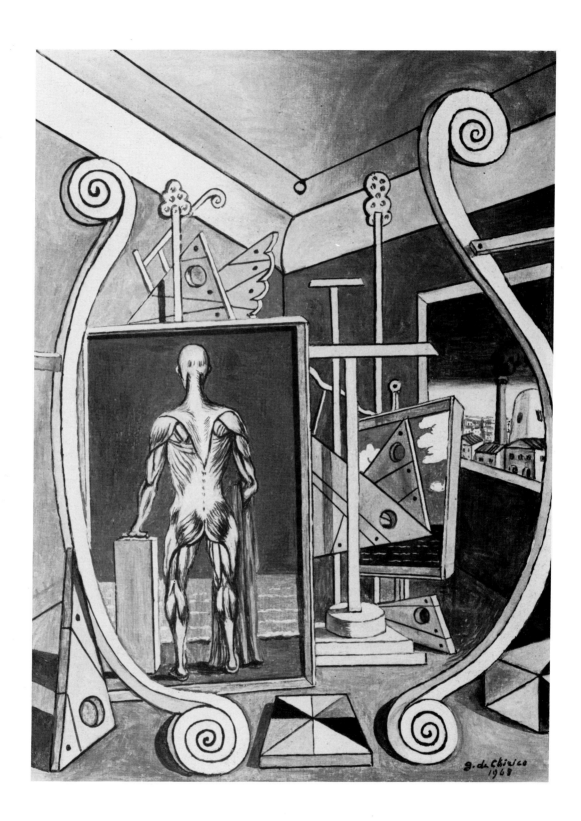

Metaphysical Interior with Anatomical Nude
1968

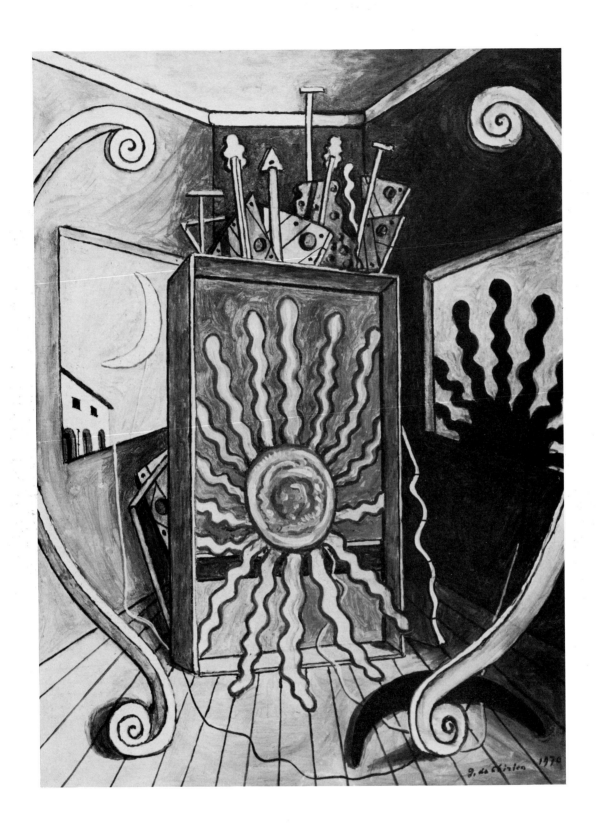

Sun in Metaphysical Interior
1971

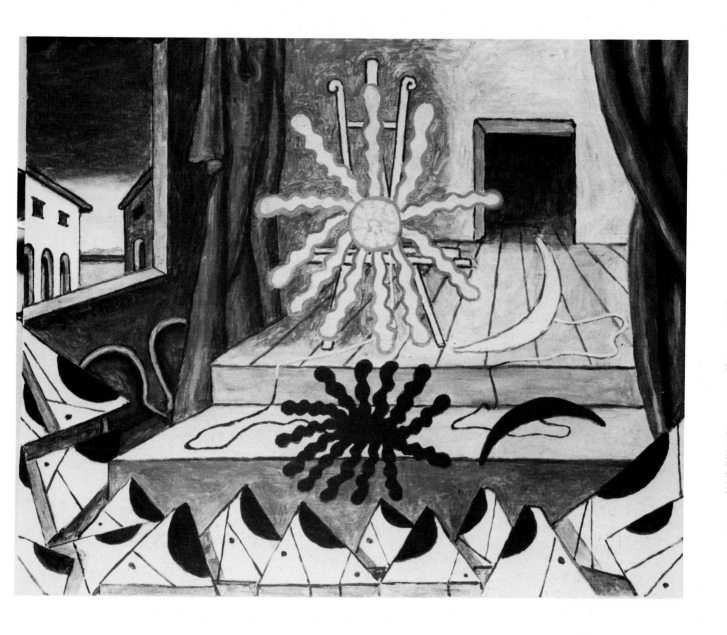

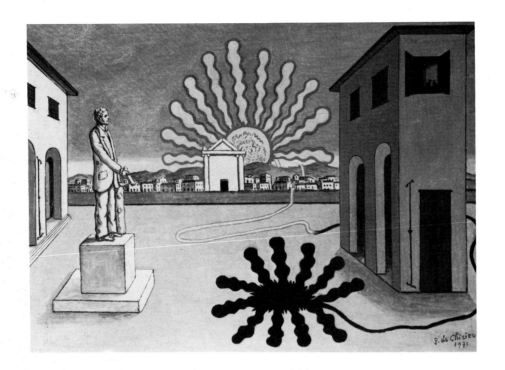

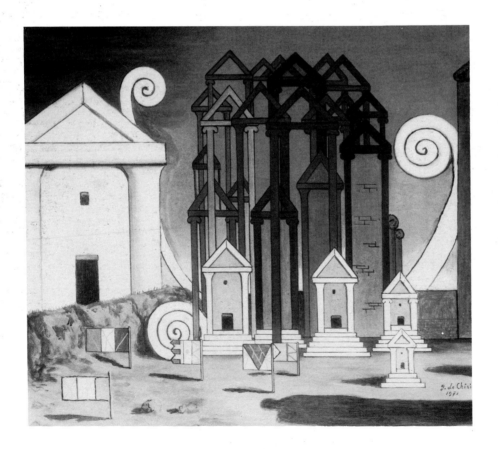

The Thermopylaes 1976

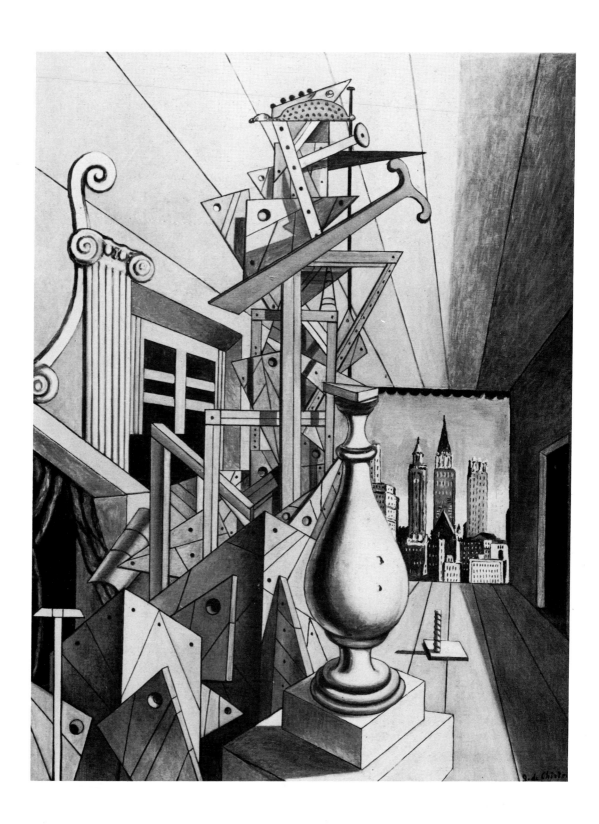

Metaphysical Vision of New York
(The Enigma of the City)
1975

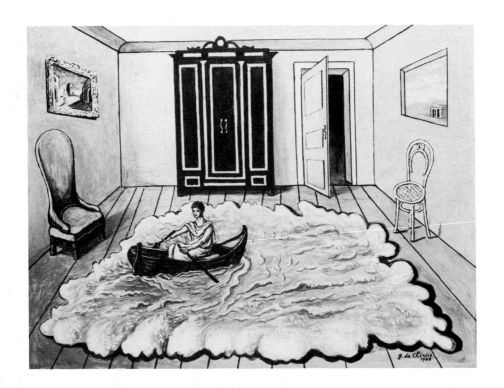

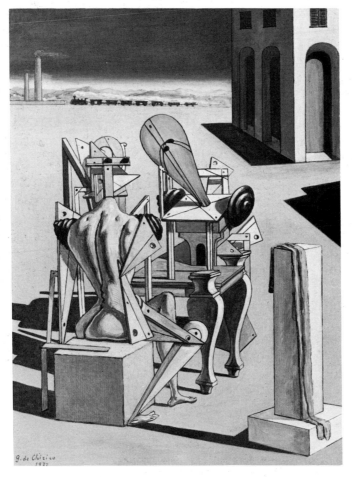

Meeting of Two Philosophers in a Square 1972

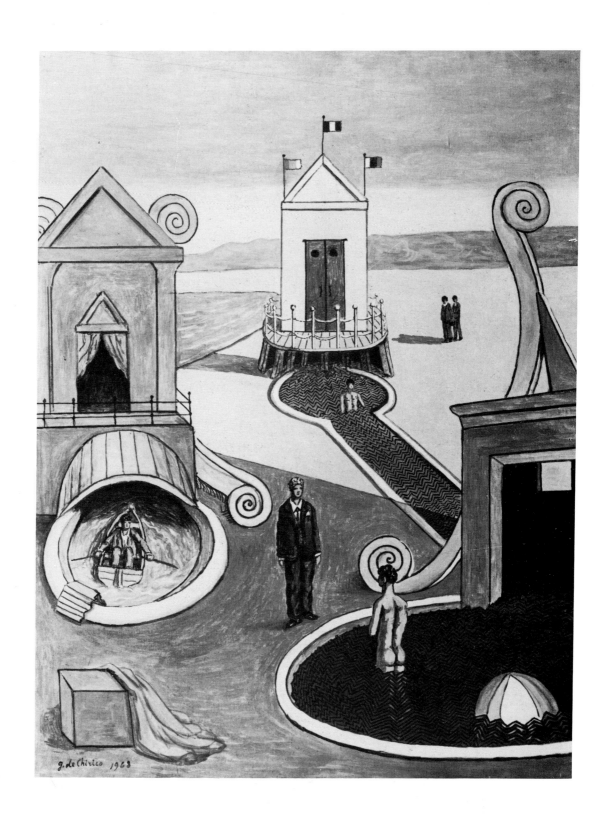

**Mysterious Baths – Flight towards the Sea
(Departure of Hebdomeros)**
1968

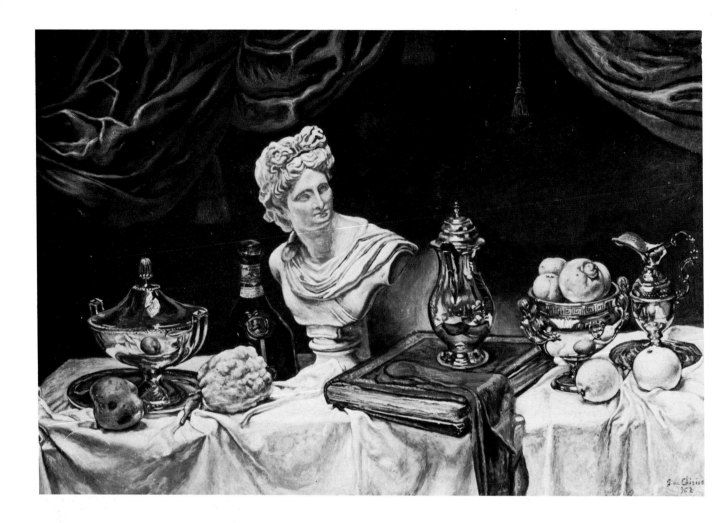

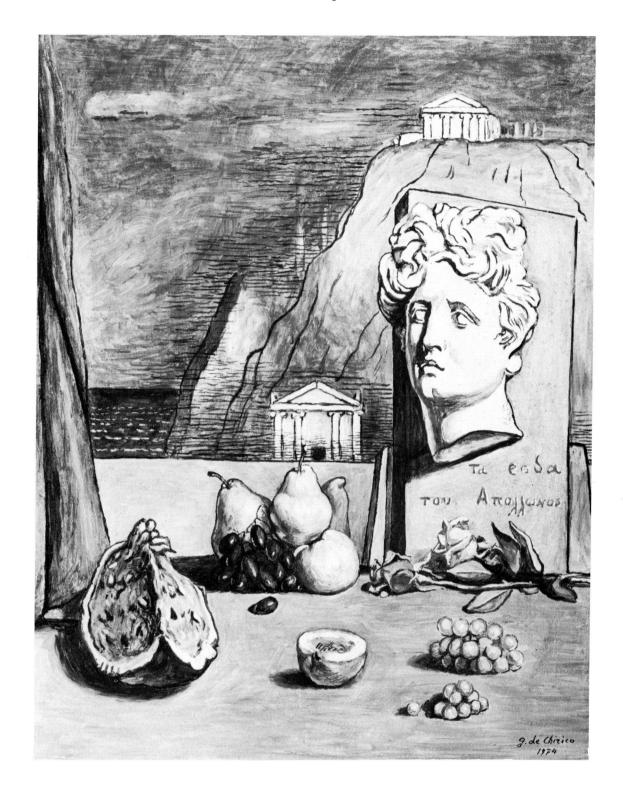

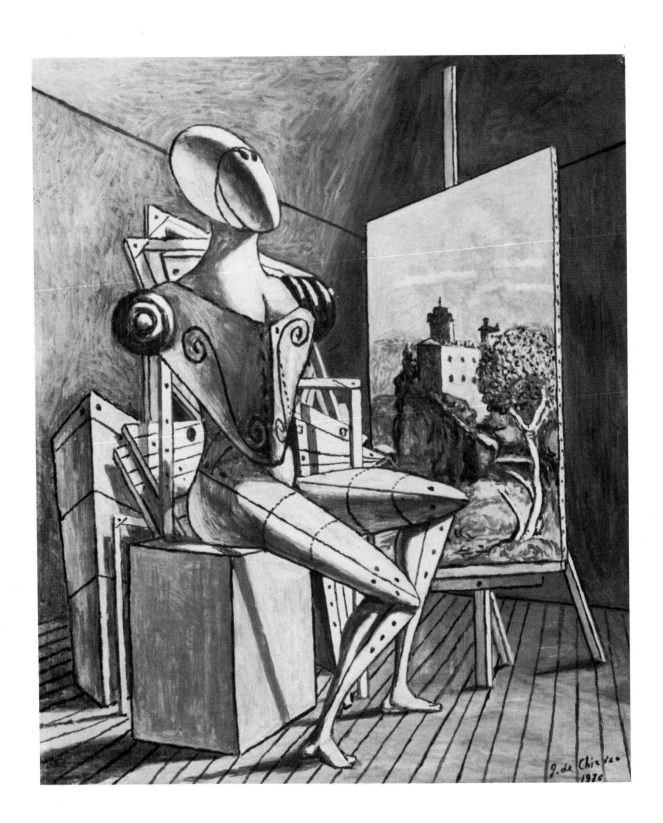

Mannequin Contemplating a Landscape
1976

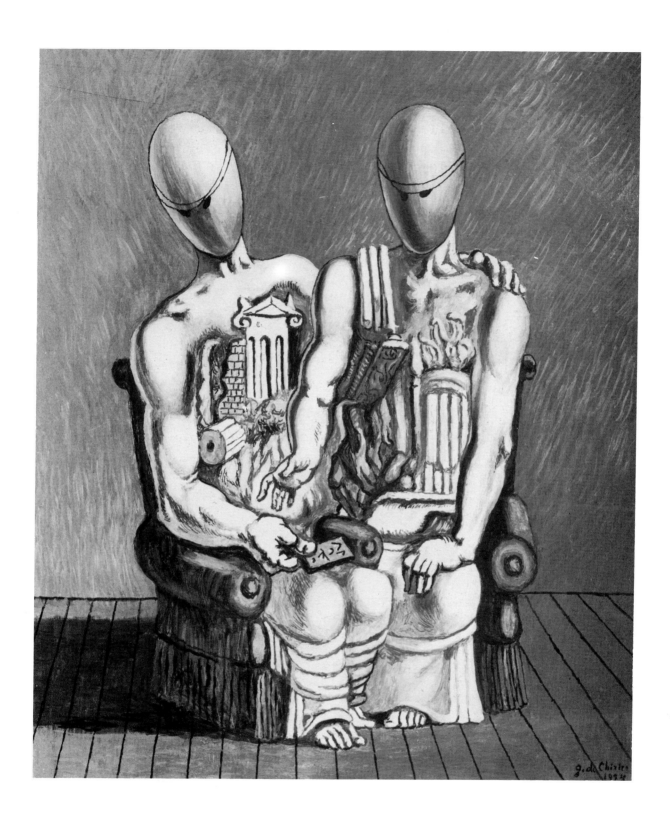

The Enigma of the Greek Relics
1975

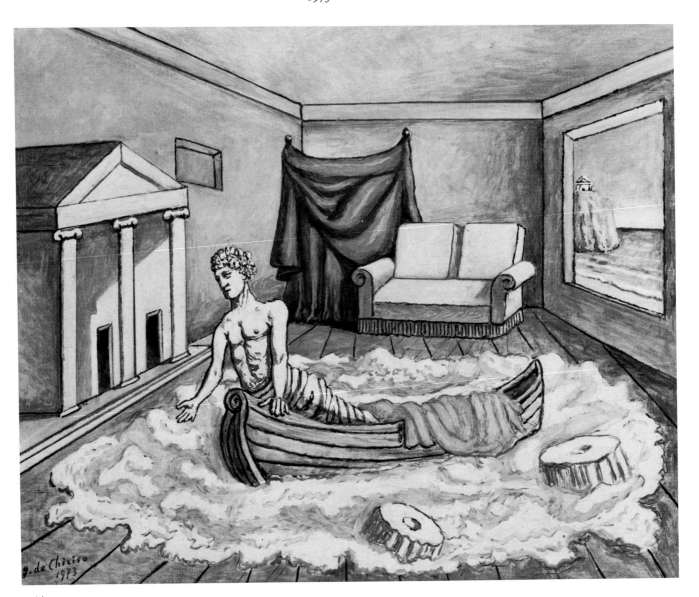

Maurizio Fagiolo dell'Arco
Eight Selected Paintings

I
The Great Game (Piazza d'Italia)
1971

This picture recreates a painting of 1913 (now at the Barnes Foundation, Philadelphia) with one disquieting variation. The set-squares of the first version mixed with other objects of the painter's studio have been turned into strange characters. The calm of the piazza bathed in twilight shadows (the evening is one of the three fundamental times of day according to the Orthodox canon of Greece where de Chirico was born) is threatened by a strange presence. The spirit of the picture is not only Metaphysical but, as it were, beyond the Metaphysical – an enigma multiplied by itself, a reply that is in reality a reflection on the past and present, a critical analysis of what has already been said, which inevitably contains all the new things to say (the unsaid).

II
The Remorse of Orestes
1969

A neo-Metaphysical picture can also help to explain a Metaphysical masterpiece. The two figures in the *Piazza d'Italia* (No. 1) represent Orestes and Pylades, the two mythical companions, and perhaps symbolize Giorgio and his brother Alberto Savinio. Here Orestes, whose appearance recalls one of the painter's mannequins, is shown in a Ferrarese room framed by the volutes of the illustrations for Apollinaire's *Calligrammes,* 1930. Attached to him is a strange, serrated shadow signifying remorse. Shadows in Metaphysical pictures are generally associated with the end of the day, with disquietude and mystery. But here the shadow contains another truth. De Chirico once wrote, 'There is nothing more mysterious in all the centuries of history than the shadow of a walking man'. Mysterious, naturally, for those who know how to meditate and interpret in a melancholy vein the 'hermetic signs' of the true Metaphysician.

III
The Mysterious Performance
1971

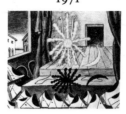

In this picture, de Chirico revives a motif from his illustrations for Apollinaire: the sun on the easel accompanied by its own shadow, repeated by the moon also with its shadow. The sun is the object of the painting, but the whole scene is in the nature of a performance. And de Chirico shows it on a proper stage – as he did with *The Disquieting Muses,* except that here there is the addition of a stage curtain and an auditorium full of eyes reproduced exactly from a masterpiece of 1916. 'One must discover the daemon, in everything', wrote de Chirico during the heroic Valori Plastici phase, adding immediately afterwards, 'one must discover the eye of everything'. The ghostly aspect of reality shown in this picture has a cyclical connotation: between 1916 in Ferrara and 1930 in Paris there stretched over the painter's work a veil of enigmas which was to be partly lifted in Rome in 1971.

IV
Angelica and Ruggero
1954

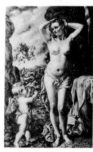

After exploring all the stages of history (or rather, after stopping in each room of an ideal museum of history) de Chirico found himself coming to grips with Rubens and the Baroque. This seems incongruous for an artist who, around 1914, was among the leading lights of the avant-garde and who, later in 1920, proclaimed himself *'pictor classicus'*. However, this revisitation of the Baroque with all its rich material and luxuriant compositions is yet another example of de Chirico's cultural nomadism. His reluctance to have labels pinned on him, his urge to flit around in whatever sphere of the imagination he chose was, in itself, a Metaphysical attitude.

V
The Return to the Castle
1969

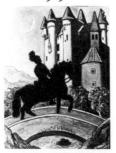

Over a humpback bridge suspended between two hillocks, passes the serrated shadow of the knight on his return home, a castle that was already present in the artist's Paris pictures of 1914. Beneath de Chirico's first self-portrait – the one in a melancholy pose that was exhibited in Paris at the Salon d'Automne in 1912 – he wrote ET QUID AMABO NISI QUOD AENIGMA EST (And what shall I love if not an enigma?). And from then on he assiduously circulated his enigmas which people could only understand (or flatter themselves they understood) by studying precisely each and every piece of his work: a picture of 1912, another of 1930, a letter dated 1914, a page of a novel written in 1929, a sketch for a stage design, a neo-Metaphysical painting etc. The eternal homecoming is that of 'the prodigal son', and the homecomer always wants to say something fundamental: perhaps that he has never really left, or never changed, that he has been obstinately saying the same things all his life, in enigmas.

VI
The Return of Ulysses
1968

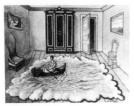

Here we have a room full of 'furniture in the valley' decorated with a picture of a 'piazza d'Italia' which is a window; and a window which is a picture; with a floor reminiscent of the disquieting 'mysterious baths'. In this room there takes place the umpteenth homecoming. The theme, which first appeared illustrating *Hebdomeros,* is of the wandering Ulysses (the *alter ego* of the Greek/universal Giorgio de Chirico) returning to Penelope in the troubled tranquillity of a Metaphysical interior. The picture is in fact a development of numerous motifs elaborated during the period of de Chirico's return to Paris (from 1924, the year when Surrealism was officially born, to 1929, the year of the Wall Street crash). During this period, de Chirico carried out some mythical Metaphysical painting of the highest quality and ended up (with all due respects to Breton) as the most surrealist of the Surrealists.

VII
The Mysterious Animal
1975

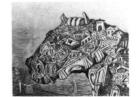

In the manner of Giuseppe Arcimboldi, we have a visible form composed of many other less easily distinguishable forms. Houses, temples, columns, acropolises go to make up a new image which is still more an evocation of the ancient world. This figure of a horse is a kind of tribute to Nietzsche, patron of the Metaphysical, whose madness started to come on in 1888, the year of de Chirico's birth. Nietzsche's Zarathustra was reborn in de Chirico's Metaphysics because the artist obeyed his first command to go back over everything that had already been done (the constant revisitation, the vicious circle, the serpent of time that bites its own tail in the cycle of eternity).

VIII
Enigma of a Hotel Room in Venice
1974

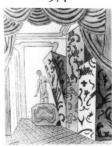

De Chirico always talked about the acute anguish hidden in furniture. He saw furniture as the active presence of an ancient ritual, an envelope containing all sorts of things including the dreams of whoever might be occupying the room. And what is more disquieting than a hotel? A place where presences are superimposed on each other like the visions of *Hebdomeros,* where a screen can hide Olympus or a hanging can become a stage curtain, or where the floor in perspective is transformed into a view. The game is the usual one: to see the world all around you but with the 'eye of the spirit', to transform it with the eye of the visionary into something *else.* The surrealism of Apollinaire (and later of Breton) was born, and not by chance, from the Metaphysical works of Giorgio de Chirico.

On the Metaphysical Aspect of Things

So we come to the metaphysical aspect of things. By deduction one can conclude that everything has two aspects: the current one which we almost always see and which is seen by people in general, and the other one, that is to say the spectral or metaphysical aspect which can be seen only by rare individuals in moments of clairvoyance and metaphysical abstraction, in the way that certain bodies concealed by materials opaque to the sun's visible rays can appear when subjected to other electromagnetic wavelengths such as x-rays.

From *Sull'Arte Metafisica (On Metaphysical Art)* in *Valori Plastici* 1919

On the Quality of Painting Materials

In approaching their work, our painters should take the greatest care in perfecting their materials: canvases, colours, brushes, oils, varnishes should all be chosen from those of the highest quality. Unfortunately, colours today are abysmal. This is due both to the roguery and trickery of the manufacturers and the mania for rush and hurry which afflicts modern painters. So the retailers offload third-rate products knowing full well that no artist will chance to complain. It would be a good idea if painters were to revive the excellent and age-old practice of preparing their own canvases and colours. It would admittedly take a little extra patience and effort; but when the painter grasps that a picture is not meant to be executed in the shortest period of time with the sole object of being shown in an exhibition and sold to a dealer, and he must needs work on it for months at a stretch – perhaps even years – without even then completing it to his innermost satisfaction; when the painter understands this, then he will happily sacrifice a couple of hours out of his working day preparing his own canvases and grinding his own colours. He will do these things with love and care; and he will be assured of materials that are consistent and reliable – at less cost.

From *Il Ritorno al Mestiere (The Return to Craft)* in *Valori Plastici* 1919

On the Importance of Drawing for a Painter

Our masters, first and foremost, used to teach us drawing; drawing the divine art, the basis of every plastic construction, the skeleton of every good work, the eternal law that every craftsman should follow. Drawing, ignored, neglected, deformed by all modern painters (and I say all, including the various professors of the realm and those who have decorated the halls of parliament), this drawing will not 'come back into fashion', as people now say when talking of artistic events, but will come back out of sheer blinding necessity, as a condition – a *sine qua non* – of valid artistic creation.

Ingres said, *'Un tableau bien dessiné est toujours assez bien peint.'* And I think he understood rather more about the subject than all modern painters put together. Just as, at election time, we in Italy, in inviting citizens to the ballot box, talk of calling them 'to the urns', so we – who were the first to set a good example in painting – should invite our painters, redeemed and redeemers alike, 'to the statues'. Yes, gentlemen, to the statues; to the statues to learn in all its nobility the doctrine of drawing; to the statues to dehumanize yourselves a little – you who, despite your devilries, are still 'human, too human'. If you have not the time and means to go and copy sculpture in a museum, if in the academies they have not yet adopted the system of obliging the future painter to study marble and plaster figures for at least five years, if the new day of laws and standards has not yet dawned, have patience but do not lose time: buy yourselves an ordinary plaster cast (it does not have to be the reproduction of an old masterpiece) and then in the silence of your room copy it ten, twenty, a hundred times; copy it until you have finally done a satisfying piece of work, drawing a face, a hand, a foot so that, as though by a miracle, it assumes its own form with all the bones, muscles, nerves and tendons in place – as they are in life.

From *Il Ritorno al Mestiere* in *Valori Plastici* 1919

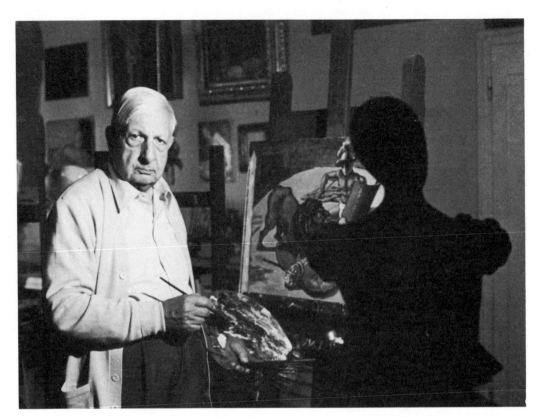

The artist in his Rome stud
Piazza di Spagna, 1970

52

Giorgio de Chirico was born on 10 July 1888 at Volos in Greece, son of Evaristo de Chirico and Gemma Cervetto. His father belonged to an aristocratic family that had settled in Tuscany but came originally from Sicily. His mother was Genoese. Three years later his brother Andrea was born, in Athens. This was the brother who was later to take the name of Alberto Savinio. The family returned to Volos, where they remained until 1899, and it was during this period that Giorgio received his first drawing lessons.

In 1899 the de Chirico family moved back to Athens. There Andrea studied music and Giorgio enrolled at the Polytechnic where he followed a course of drawing and painting. In 1900 he painted his first picture.

In 1905 the boys' father – a railway engineer engaged on building the Athens to Salonika line – died, and their mother decided to abandon Greece for Germany, choosing Munich as a place that would offer her sons a better cultural environment for their studies. After a brief stay in Italy (Venice, Milan, Florence) they reached Munich in 1906. There Giorgio attended the Academy, where he discovered Böcklin and Klinger. He also studied Nietzsche, Schopenhauer and Weininger. His mother and brother then left him and moved to Milan, which was considered a more suitable centre for Andrea's musical education. In 1908 Giorgio joined them there and it was during this period that he painted the first pictures we know of, inspired by the works of Böcklin.

The family then moved to Florence, and in 1911 Giorgio and his mother (preceded the previous year by Andrea) decided to go and live in Paris, where they arrived on 14 July having stopped off in Turin (a city that had links with Nietzsche). During the next year, 1912, Giorgio – thanks to the interest of a music critic who was a friend of his brother – had the first public showing of his works, at the Salon d'Automne. He made the acquaintance of the writer and critic Guillaume Apollinaire and through him came to know Picasso, Braque, Brancusi, Derain and Max Jacob. In 1913 he exhibited at the Salon des Indépendants, (it was from that moment that Apollinaire began to follow his work with attention and interest), and he also continued to exhibit at the Salon d'Automne, where he sold his first picture. In 1914, through Apollinaire, he met the dealer Paul Guillaume with whom he signed a contract. He exhibited again at the Salon des Indépendants.

By 1915, following the outbreak of World War I, many of the Paris group had dispersed. Apollinaire left for the front (whence he later returned with a wound in his head at the spot prophetically indicated by de Chirico, in a portrait of him completed the year before). The de Chirico brothers returned to Italy where they too joined up, at the recruiting office in Florence. From Florence they were posted to Ferrara and their mother joined them there. De Chirico, however, kept close links with Paris; he renewed his contract with Paul Guillaume and maintained contact

with the Dadaists. In Ferrara he got to know Filippo De Pisis and – through Ardengo Soffici and Giovanni Papini – Carlo Carrà, with whom he spent a certain period in a military hospital for nervous illnesses. It was at this time that Carrà painted his first pictures influenced by de Chirico's view of the world. Thus was born what was later to become dubbed Metaphysical painting, of which the art review *Valori Plastici*, published by Mario and Edita Broglio (to which de Chirico contributed from the start) was to be the theoretical exponent. In autumn 1918 de Chirico secured a transfer to Rome, where he lived with his mother in straitened financial circumstances. He threw himself into Rome's artistic life, collaborating with the Valori Plastici group and with the Futurists and Dadaists. Meanwhile, the critics had already noted his work when first shown in Italy at an exhibition the previous May.

In February 1919, at the Bragaglia gallery in Rome, de Chirico had his first one-man show. But it was not well received. Only De Pisis gave it an enthusiastic review, and Roberto Longhi panned it. Worse, only one picture was sold. In the autumn of 1919 he signed a contract with Mario Broglio for the exclusive rights to his pictorial and literary output, and the review *Valori Plastici* published the first monograph on him. It was from the early months of 1919 that de Chirico started to frequent the great museums and began to fall under the spell of the old masters.

Between 1920 and 1921 de Chirico lived between Rome, Florence and Milan and contributed to various important exhibitions. His first one-man show in Milan, where he exhibited his Metaphysical works together with others reflecting more recent developments, evoked little comment.

In France, from 1922 to 1924, the Surrealists, having a fixed idea of de Chirico as a Metaphysical artist, greeted his newer works with mistrust, and this created an uneasy relationship which in later years deteriorated into open disagreement. De Chirico's recent works exhibited at the Rome Biennale in 1923 were, with a few exceptions, not well received. However, some were bought by the French poet Paul Eluard who with his wife Gala had come specially to Rome to see them. Two pictures which marked the artist's first appearance at the Venice Biennale, in 1924, did not find favour with the critics.

It was in 1924 that he met in Rome (where he was living with his mother and brother) a Russian dancer, Raissa Gurievich Krol, whom he later married. In the autumn of the same year he went to Paris – where he still had good connections with the art world – to design the sets and costumes for a ballet (music composed by Casella) based on Pirandello's short story *La Giara*. At around this time his more recent works began to attract attention and his pictures were seen in Italy, the United States, France, England, Japan and Scandinavia.

In 1925 Giorgio and Raissa made their home in Paris, where de Chirico was acknowledged by the Surrealists as their inspirer and master. However, being so wedded to his Metaphysical paintings, they were unable to appreciate his subsequent works. André Breton considered them degenerate and attacked them on the occasion of de Chirico's one-man show held in May 1925 at the Léonce Rosenberg gallery. By 1926 the break between de Chirico and the Surrealists was complete.

During these years de Chirico started exhibiting in Italy and abroad with the Novecento group and contributed to shows both in England and the United States. Meanwhile critics began taking an interest in his more recent works, and in 1928 Waldemar George devoted a monograph to his new phase.

In the same year Jean Cocteau wrote a loving and admiring essay on the artist entitled *Le Mystère Laïc*. But de Chirico seemed wholly preoccupied with pursuing his own exclusive line in the contemporary scene and for the moment did not respond to Cocteau's gesture.

In 1929, some years after de Chirico had made his final break with the Surrealists, *Hebdomeros* was published. This masterpiece of surrealist writing proved to be his most important literary work and was described by Louis Aragon as a 'work of infinite beauty'. All this while, he was very active exhibiting, sometimes on his own and sometimes with others. Museums were acquiring a taste for his pictures, while avant-garde artists and critics waited to see what he was going to produce next.

In 1931, in Paris, Giorgio de Chirico met Isabella Far, a Russian emigrée, who became his second wife and with whom he remained until the day of his death. In 1932 Giorgio and Isabella visited Florence where they became close friends with the family of the antiquarian Luigi Bellini. The same year de Chirico exhibited at the Venice Biennale in a section presented by the painter Gino Severini and devoted to 'Italians in Paris'.

Until 1935, when he left for the United States, de Chirico paid numerous visits to Italy, and especially to Milan, for the purpose of stage designing and showing his paintings. During this time he evinced, as always, a profound interest in the practical problems of painting. However, his recent more 'verist' paintings did not meet with unanimous critical approval. In 1936 Isabella joined him in New York and remained there with him until his return to Italy in January 1938. This American interlude was a success. Many of his works were bought by important collectors and museums; he contributed to *Vogue* and *Harper's Bazaar*; he also received commissions for interior design including the painting of wall panels.

On returning to Italy in 1938 the de Chiricos took up residence in Milan, where Giorgio occupied himself with several exhibitions. But he did not stay there long and was soon on the move once more. In 1939 he was off to France. Then in 1940 he returned to

Italy and lived for two years between Milan and Florence, where he and Isabella were summer guests of the antiquarian Bellini. He exhibited in Turin, Milan and Florence, showing new naturalist subjects and various portraits. Internationally, however, de Chirico's shows were concentrated exclusively on his Metaphysical works. In the 1942 Venice Biennale he displayed numerous works, but only the poet Libero De Libero accepted these unreservedly and other critics talked about a 'Baroque' phase weighed down by elements revived from the 16th and 17th centuries.

In 1944 the de Chiricos settled in Rome. By now his more recent pictures had become the subject of fierce controversy, being not yet understood by the generality of critics who, however, nearly forty years later, would have adopted these same pictures as a point of departure for new developments in Italian painting.

In July 1946 de Chirico declared that all the canvases dating from 1910 to 1920, attributed to him and on exhibition at the Allard gallery in Paris, were fakes. Thus began the arguments on the authenticity of his works which continued with increasing bitterness over the years, ending with the sensational law suit in Florence in which the artist's intransigent attitude was explained and justified – an attitude consistently supported and defended by his wife Isabella, even after his death.

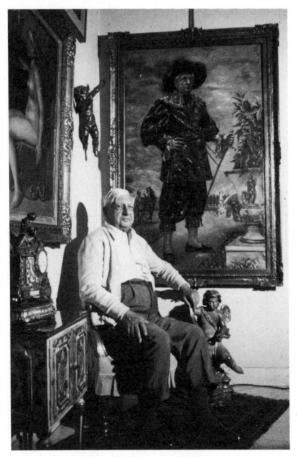

Giorgio de Chirico at home, 1970,
with **Self-Portrait in a Park** 1959

In 1948 the Venice Biennale prepared an exhibition of paintings favouring the artist's Metaphysical period at the expense of his later works. De Chirico reacted strongly and stated that one of the pictures attributed to him was a forgery.

In the course of his lifetime de Chirico was never granted any official recognition in Italy, but in 1948 he was made a member of the Royal Society of British Artists through whom he put on a one-man show in 1949 comprising over a hundred works. In opposition, the London Gallery arranged an exhibition of his Metaphysical pictures to run concurrently.

Most of the works shown by de Chirico in London were displayed the same year in Venice at the Salone degli Specchi di Ca' Giustinian. The show was organized by Giorgio Zamberlan and was intended as a gesture of protest at the Biennale's selection of the year before. Given the climate at that time, it is unsurprising that followers of the abstract school reacted violently. In 1950 de Chirico – still pursuing his quarrel with the Biennale – organized an 'Anti-Biennale' of realist painters at the Società Canottieri Bucintoro. In 1952 and 1954 he followed up with one-man shows which similarly took the form of anti-Modernist demonstrations.

Meanwhile the artist continued to exhibit prolifically and regularly in Venice, Genoa, Rome, Turin and Milan. In his work the Metaphysical themes of former years were openly revived, while new Metaphysical motifs were added; he went on painting still lifes with landscape backgrounds together with portraits and interiors, all the while attacking modern painting, never missing an opportunity to quarrel with contemporary art, denouncing the numerous fakes that were invading the market, working in a spirit of free expression and – as always – completely his own man, detached from all other artistic trends and currents.

In 1953, 1966 and 1968 Isabella Far devoted three monographs to Giorgio de Chirico. During the 1960s the artist was intensely active in the production of lithographs featuring his characteristic themes, for the most part Metaphysical and classical. In 1964 he resumed stage designing. Towards the end of the 1960s he began a new line that he was to continue until his final years: creating in bronze, sculptures which conveyed in three dimensions the characters of his Metaphysical world, as well as his classical horses. Later he applied himself to the creation of multiples in silvered or gilded bronze, as well as jewellery in silver and silver-gilt.

From 1946 to 1966 Giorgio de Chirico was under exclusive contract to the gallery owners Antonio and Ettore Russo. A further contract intended to expire in 1968 was cancelled by the artist in 1967. The same year Giorgio de Chirico and Isabella Far signed a contract with the gallery owner Claudio Bruni Sakraischik to publish in several volumes a general catalogue of the artist's works. Six volumes were

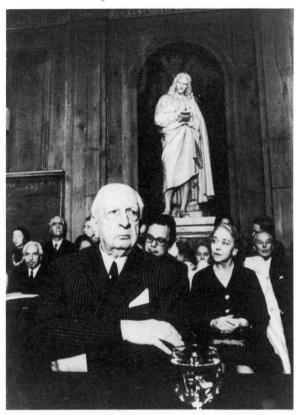

brought out between 1971 and 1977. The seventh volume, which appeared in 1984 (six years after the artist's death and without his widow's authorization as specified in the contract), is at present the subject of litigation. Claudio Bruni Sakraischik organised several de Chirico exhibitions in his Rome gallery, La Medusa, and elsewhere.

The entire span of de Chirico's activity was covered by an anthology of his works shown at the Palazzo Reale in Milan in 1970.

In 1972 the de Chiricos went to Greece for the making of Franco Simongini's documentary *Giorgio de Chirico: The Mystery of the Infinite* – a return of the artist to his roots which assumed a kind of emblematic significance.

Sought after by collectors, loved by the public, but opposed by official institutions and a section of the professional critics in Italy, de Chirico in the 1970s received ample recognition from abroad. In 1974 he was appointed a member of the French Academy, and in 1976 he was awarded the Commander's Cross of the Order of Merit of the Federal Republic of Germany. Meanwhile numerous exhibitions were arranged with the help of Isabella Far (among the most important being the exhibition held at the New York Center in 1972, an exhibition which toured various Japanese museums in 1974, and the anthology shown at the Marmottan museum in Paris in 1975). In 1978 Giorgio de Chirico, whose works were now starting to be analysed with renewed interest, reached the age of 90, and a celebration was arranged at the Campidoglio in

Rome with addresses given by G.C. Argan, M. Calvesi and Nello Ponente. However, an attempt to arrange an official exhibition at the Campidoglio devoted to the artist's works – a proposal supported by Maurizio Fagiolo dell'Arco who in recent years has made a particularly close study of de Chirico's works in all their different periods – unhappily came to nothing. The Campidoglio's doors still remain closed to the works of this great, misunderstood master. Instead, the commemorative exhibition, promoted by Isabella Far, was put on abroad, at Artcurial in Paris.

On 20 November 1978 Giorgio de Chirico died in Rome.

With the arrival of the 1980s different museums started arranging large retrospective shows which were of varying interest depending on the critical standpoint of the organizers. The first was at the Galleria Nazionale d'Arte Moderna in Rome (1981). Then came the Museum of Modern Art in New York (1982), followed by the Tate Gallery in London (1982), the Kunsthaus in Munich (1982) and the Centre Georges Pompidou in Paris (1983). To coincide with the last, Artcurial in Paris put on show a lavish selection of de Chirico's Metaphysical pictures dated from 1950 to 1975, which was favourably received by the French critics.

In 1982 the 'Giorgio de Chirico Foundation' was set up in Rome on the initiative of Claudio Bruni Sakraischik and is still awaiting official recognition. In 1983 Isabella Far de Chirico applied for recognition of a 'Foundation for the Study of the Works of Giorgio de Chirico' and in 1984 began legal proceedings contesting the right of Claudio Bruni Sakraischik to use without authorisation the name of Giorgio de Chirico for his foundation. The pictures from de Chirico's atelier, which belong to his widow, have not yet all been shown in Italy. They have, however, been seen in France (at Artcurial, Paris in 1979; at the Château-Musée, Cagnes-sur-Mer in 1980; at the Musée des Beaux-Arts André Malraux, Le Havre in 1981) and also in three Japanese cities during 1982 hosted by the Seibu Museum of Art, Tokyo. All these exhibitions have been organized by Isabella Far with the collaboration of Carmine Siniscalco. In Italy, from the atelier pictures, fifteen works of classical (not Metaphysical) inspiration were shown in Rome by the Studio S/Arte Contemporanea in May/June 1983, twenty appeared in the section 'Art in the Mirror' at the Venice Biennale of 1984 selected by Maurizio Calvesi, and twenty have been shown at the exhibition 'The Return of the Knight Errant' organized by Carmine Siniscalco at the Palazzo Conti Passi, Villongo (Bergamo) for the Comune di Villongo. At the moment there is an exhibition in preparation to be held in the Palazzo Reale at Caserta. The entire *Atelier del Maestro* will be shown from July to September 1985 at the Palazzo dei Diamanti in Ferrara, where in 1981 a permanent museum was established by Maurizio Calvesi for the documentation of Metaphysical art.

Catalogue

Paintings
All paintings from private collections unless otherwise stated

**The Leopard Skin Coat
(Portrait of Isa)** 1940
oil on canvas/85×57cm

The Muse 1944
oil on canvas/55×35cm

Nude Self-portrait 1945
oil on canvas/62×51cm

Achilles at the Spring 1946
oil on canvas/70×100cm

Gladiators inside the Room 1953
oil on canvas/100×80cm

Angelica and Ruggero 1954
oil on canvas/150×100cm

Mysterious Cabins 1956
oil on canvas/60×50cm

Mysterious Baths with a Swan 1958
oil on canvas/70×50cm

Still Life with Silverware 1962
oil on canvas/138×193cm

Hippolytus and His Companions 1963
oil on canvas/109×140cm

Horses with the God Mercury 1965
oil on canvas/121×82cm

Tired Gladiator 1968
oil on canvas/83×50cm

Heads of Gladiators 1968
oil on canvas/60×83cm

**Mysterious Baths – Flight Towards the Sea
(Departure of Hebdomeros)** 1968
oil on canvas/80×60cm

Ancient Horses at the Foot of a Castle 1968
oil on canvas/76×100cm

Hector and Andromache before Troy 1968
oil on canvas/70×50cm

Furniture and Carpet in the Valley 1968
oil on canvas/100×80cm

Metaphysical Interior with Anatomical Nude 1968
oil on canvas/80×60cm

The Return of Ulysses 1968
oil on canvas/60×80cm

Battle on the Bridge 1969
oil on canvas/83×60cm

The Return to the Castle 1969
oil on canvas/90×70cm

The Remorse of Orestes 1969
oil on canvas/80×60cm

Oedipus and the Sphinx 1969
oil on canvas/90×70cm

The Thinker 1971
oil on canvas/90×70cm

Sun in Metaphysical Interior 1971
oil on canvas/80×58cm

Piazza d'Italia with Sun 1971
oil on canvas/50×70cm

The Mysterious Performance 1971
oil on canvas/50×60cm

The Great Game (Piazza d'Italia) 1971
oil on canvas/60×80cm
Artcurial Collection

Great Metaphysician with Squares 1971
oil on canvas/60×80cm

The Secret of the Bride 1971
oil on canvas/86×50cm

Meeting of Two Philosophers in a Square 1972
oil on canvas/80×60cm
Artcurial Collection

The Return of Ulysses 1973
oil on canvas/61×73cm

The Prodigal Son 1973
oil on canvas/100×80cm

Still Life with Head of Apollo 1974
oil on canvas/95×78cm
Artcurial Collection

Mystery of a Hotel Room in Venice 1974
oil on canvas/91×72cm

**Metaphysical Vision of New York
(The Enigma of the City)** 1975
oil on canvas/105×80cm

The Enigma of the Greek Relics 1975
oil on canvas/92×73cm

The Hand of Zeus and the Nine Muses 1975
oil on canvas/81×64cm

The Mysterious Animal 1975
oil on canvas/50×60cm

The Thermopylaes 1976
oil on canvas/55×65cm

Mannequin Contemplating the Landscape 1976
oil on canvas/55×65cm

Sculpture

Hippolytus 1969
silver plated bronze/edition of 9
base 36×21.5cm/46cm high
private collection

Ajax 1970
gilded bronze/edition of 9
base 20×19.5cm/41.5cm high
private collection

The Great Metaphysician 1969
gilded bronze/edition of 9
base 23×12.5cm/52cm high
private collection

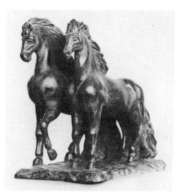

Ancient Horses 1969
bronze/edition of 9
base 34×23cm/34cm high
private collection

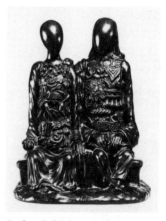

Colonial Mannequins 1970
silver plated bronze/edition of 9
base 38×27cm/49cm high
private collection

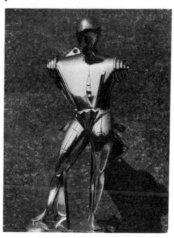

The Great Troubadour 1973
silver plated bronze/edition of 9
base 28×13.5cm/76cm high
private collection

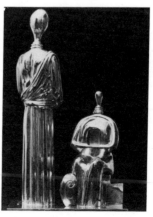

The Disquieting Muses 1973
silver plated bronze/edition of 9
base 27×20cm/49.5cm high
private collection

Drawings

All works are from the collection of Signora Isabella Far de Chirico

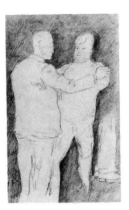

The Encounter *c.*1935
pencil/39.8×24.5cm

Portrait of Isa *c.*1940
pencil/30×33cm
illustrated on p.16

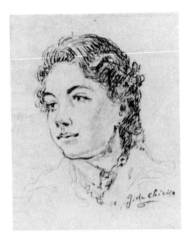

Portrait 1940
pencil/26×20cm

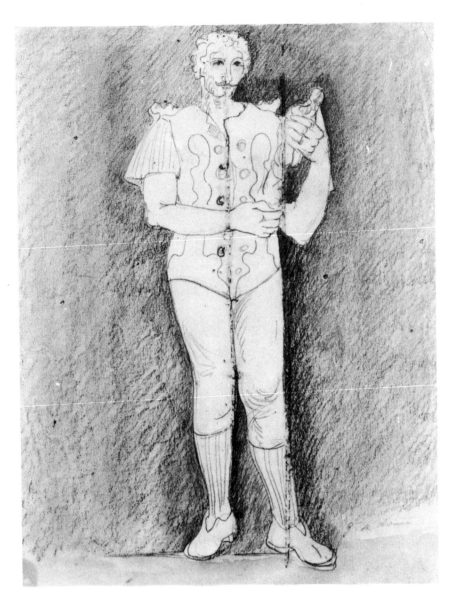

Page *c.*1940
pencil with watercolour background/30×22.7cm

Self Portrait *c.*1940
charcoal/15×12.5cm

Study of Legs *c.*1942
pencil with watercolour background/27.5×22.5cm

Landscape *c.*1945
wash/23×31.7cm

Assaulting the Castle *c.*1945
pencil/24×16cm
illustrated on title page

Figure Study *c.*1945
pencil/28.3×21cm

Figure of a Woman *c.*1945
pencil/31×22cm

The Prisoner *c.*1945
pen/23×17.5cm

The Park *c.*1945
pencil/30×22.7cm

Lucrece *c.*1948
pencil/35.5×25.5cm

Warrior *c.*1948
pencil/30×22.4cm

The Colt *c.*1950
wash/24×30.4cm

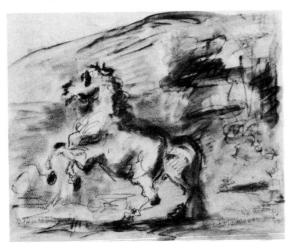

Horse and Rider *c.*1950
charcoal/17.5×24cm

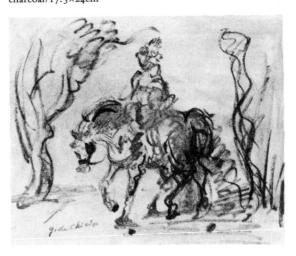

Composition with Female Figure *c.*1950
wash/17.5×26cm

The Triumph of Medicine *c.*1953
pencil/40×50cm

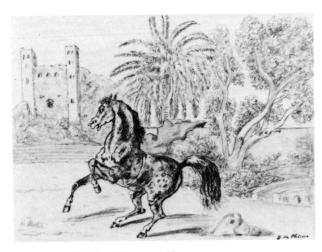

Horse and Palm Trees 1968
pencil and watercolour/36.5×50cm

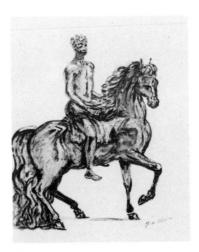

Hippolytus 1970
mixed media/50×40cm

Lithographs and Etchings

All works from the collection of Signora Isabella Far de Chirico

The number in the edition is shown as follows:
the arabic numerals indicate the number of the edition numbered with arabic numbers;
the roman numerals indicate the number of the edition numbered with roman numbers;
a–z indicates that there is a series of prints marked with the letters of the alphabet.
Artist's proofs are to be found for each subject, in black and white and/or hand-coloured.
Variations on the same theme (differences in colouring, or in the numbers of colours)
are also indicated.
Measurements with lithographs refer to the size of the paper; with etchings the size is that of the engraved plate.
All lithographs and etchings except those marked ★ have been printed by Alberto Caprini in Rome.

The Repose of Ariadne 1969
lithograph/6 colours/70×50cm
ed.99 + xxv + a–z (pink wall)
lithograph/5 colours/70×50cm
ed.99 + xxx + a–z (grey wall)

Piazza d'Italia 1969
lithograph/5 colours/60×80cm
ed.90 + ev

Sun on the Temple 1969
lithograph/6 colours/70×50cm
ed.90 + xx

Sun and Sea 1969
lithograph/6 colours/70×50cm
ed.90 + xx

The Invincible Chariot 1969
lithograph/5 colours/50×70cm
ed.99 + xxx + a–z (blue cloak)
ed.99 + xxv (red cloak)
ed.15 (black and white)

The Mysterious River 1969
lithograph/4 colours/50×70cm
ed.90 + xxv

The Solitary Poet★ 1969
lithograph/black only/100×70cm
ed.60

The Offering to Zeus★ 1969
lithograph/black only/70×50cm
ed.80 + x + x japan paper

The Dioscuri 1969
lithograph/8 colours/50×70cm
ed.90 + xv 1969

Rest by the Aegean Sea 1969
lithograph/13 colours/50×60cm
ed.75 + 21 japan paper
+ 8 without classification + 7 (pink sky)
ed.75 + 21 japan paper
+ 8 without classification + 7 (blue sky)

My Oriental Friends 1969
lithograph/5 colours/70×50cm
ed.90 + xxx

Metaphysical Interior 1970
lithograph/7 colours/70×50cm
ed.99 + xxv + a–z

The Trophy 1970
lithograph/8 colours/70×50cm
ed.99 + xxx + a–z 1970

The Guardian of Thermopylae 1970
lithograph/5 colours/100×70cm
ed.90 + xx

The Philosopher and the Muse 1971
lithograph/5 colours/70×50cm
ed.120 + xxv + a–z

The Horses of Achilles 1971
lithograph/6 colours/70×50cm
ed.95 + xxv + a–z (pink sky)
ed.95 + xxv (blue sky)
ed.90 + xxv/ 2 colours

The Muses of Music 1973
lithograph/7 colours/70×50cm
ed.99 + xxx + a–z

Ancient Horses
(or Stylised Horses) 1979
lithograph/5 colours/75×56cm
ed.99 + xxxv + a–z 1974

The Metaphysical Architect
lithograph/9 colours/70×50cm
ed.99 + xxv + a–z

Furniture in the Valley 1971
etching/31×49cm
ed.65 + xxv

The Enigma 1971
etching/37.5×30.5cm
ed.65 + xxv

The Idol 1972
etching/49×32cm
ed.65 + xxv

Conversation in the Baths 1972
etching/5 colours/43.5×32cm
ed.75 + xxx

Encounter in the Mysterious Bath 1972
etching/49×38cm
ed.65 + xxv

The Mysterious Fountain 1971
etching/35.5×31.5cm
ed.65 + xxv

Profile of a Woman 1972
etching/31×43.5cm
ed.65 + xxxv + a–z

The Child 1971
etching/42.5×31.5cm
ed.65 + xxv

The Mysterious Hand 1972
etching/41.5×31cm
ed.75 + xxv

Troubador with Chimney 1974
etching/6 colours/49×35.5cm
ed.99 + xxv + a–z

The Muse of History 1970
etching/2 colours/70×50cm or 39.5 × 27.5cm
ed.48 + xv (nocturnal light)
ed.48 + xv (sunlight)
ed.48 + xv (afternoon light)

Chronological Bibliography

Books by Giorgio de Chirico

1925 *Gustave Courbet*, Rome, 1925
1928 *Piccolo Trattato di Technica Pittorica*, Milan, 1928, Edition in manuscript facsimile, 1945.
1929 *Hebdomeros, le Peintre et Son Génie chez l'Écrivain*, Paris, 1929.
1938 *Deux Fragments Inédits* (collection *Un Divertissement*), Paris, 1938
1945 *1918–1925, Ricordi di Roma*, Rome, 1945
 Une Aventure de M. Dudron, Paris, 1945
 Memorie della Mia Vita, Rome, 1945

Illustrated Books by Giorgio de Chirico

1924 Massimo Bontempelli: *Siepe a Nord-Ovest*, Rome, 1924
1928 Paul Eluard: *Défense de Savoir*, Paris, 1928
 Jean Cocteau: *Le Mystère Laïc, Essai de Critique Indirecte*, Paris, 1928
1930 Guillaume Apollinaire: *Calligrammes*, Paris, 1930
1934 Jean Cocteau: *Mythologie*, Paris, 1934
1941 *L'Apocalisse*, edited by Raffaele Carrieri with a preface by Massimo Bontempelli, Milan, 1941
1965 Allessandro Manzoni: *I Promessi Sposi*, Milan, 1965
1968 *Iliade*: episodes translated by Salvatore Quasimodo, Milan, 1968
1969 Franz Kafka: *Auf der Galerie*, Frankfurt, 1969

Illustration to
Apollinaire's *Calligrammes*, 1930
lithograph

Writings of Giorgio de Chirico

1914 *The Enigma of a Day*, Farmington, Maine, 1914

1916 *Hector and Andromache*, New York, 1916

1918 *Il Signor Govoni Dorme* in Alberto Savinio, *Hermaphrodito*, Florence, *La Voce*, 1918

1919 *Noi Metafisici* in *Cronache d'Attualità* (Bulletin of la Casa d'Arte Braglia), Rome, 15 February 1919
 Sull'Arte Metafisica in *Valori Plastici*, Rome, 1918/19, 4/5
 Impressionismo in *Valori Plastici*, Rome, 1918/19
 Il Ritorno al Mestiere in *Valori Plastici*, Rome, 1918/19

1920 *Paolo Gauguin* in *Il Convegno*, Milan, 1920
 Raffaello Sanzio in *Il Convegno*, Milan, 1920
 Arnoldo Böcklin in *Il Convegno*, Milan, 1920
 Il Senso Architettonico nella Pittura Antica in *Valori Plastici*, Rome, 1920
 Classicismo Pittorico in *La Ronda*, Rome, 1920
 Gaetano Previati in *Il Convegno*, Milan, 1920
 Max Klinger in *Il Convegno*, Milan, 1920

1921 *La Mania del Seicento* in *Valori Plastici*, Rome, 1921
 Riflessioni sulla Pittura Antica in *Il Convegno*, Milan, 1921

1922 *Une Lettre de Chirico* in *Littérature*, Nouvelle série, Paris, 1922
 Giorgio Morandi in *Catalogo della Fiorentina Primaverile*, Florence, 1922

1923 *Protechnica Oratio* in *La Bilancia*, Novara, 1923

1924 *Un Rêve* in *La Révolution Surréaliste*, Paris, 1924/25

1925 *Vale Lutetia* in *Rivista di Firenze*, Florence, 1924/25
 Espoirs ; Une Vie ; Une Nuit (three poems, 1911–1913) in *La Révolution Surréaliste*, Paris, 1924/25

1926 Preface to the catalogue of the exhibition *Filippo De Pisis* at the Sacre du Printemps gallery, Paris, 23 April–7 May 1926

1927 *Statues, Meubles et Généraux* in *Bulletin de l'Effort Moderne*, Paris, 1927

1928 *Le Fils de l'Ingénieur* in Waldemar George, *Chirico*, Paris, 1928, pp.XXVII–XXXII

1929 *A l'Italie, Lassitude, Odisseus, Cornelia, Souvenir d'Enfance, Sur la Mort de Mon Oncle* (poems), in *Sélection, Cahier*, Antwerp, 1929 (special number devoted to Giorgio de Chirico)

1930 *Un Giorno Tu Sarai Qualcuno* in *Poligone*, Milan, February 1930
 L'Epodo (1925), in E. Vittorini, E. Valqui: *Scritti Nuovi Lanciano*, 1930
 Bambole, Personaggi in *Belvedere*, Milan, May/June 1930
 Saluto a Spadini in *Omaggio a Spadini*, Rome, 1930

1933 *Bataille Antique* (three poems in French) in *Circoli*, Genoa, 1933 (January/February)

1934 *Sur le Silence* in *Minotaure, Revue Artistique et Littéraire*, Paris, 1934

1936 *Aurore, Souvenir, Phileas Fogg, Nemrod, Antibes, C'est Dimanche* in *L'Italiano*, Rome, 1936

1938 *Barnes Collezionista Mistico* in *L'Ambrosiano*, Milan, February 1938
 J'ai Été à New York in *XXe Siècle*, Paris, March 1938
 Vox Clamans in Deserto (.,…,…) in *L'Ambrosiano*, Milan, 23 and 30 March 1938
 Le Mystère de la Création, Mystery and Creation in *The London Bulletin*, London, 1938

1940 *Una Gita a Lecco* in *Aria d'Italia*, Milan, 1940
 Il Signor Dudron (fragment of novel), in *Prospettive*, Rome, 1940
 Brevis pro Plastica Oratio in *Aria d'Italia*, Milan, 1940

1941 *Perché Ho Illustrato l'Apocalisse* in *Stile*, Milan, January 1941
 Gregorio Sciltian in *Stile*, Milan, April 1941

1942 *Due Prose* in *Beltempo, Almanacco delle Lettere e delle Arti*, Rome, 1942

1943 *Sulla Pittura* in *Pattuglia*, Forli, 1943

1949 *Diktator der Modernen Kunst* in *Echo der Woche*, Munich, 15 July 1949

1951 *Propaganda Modernista* in *Minosse*, Venice, 30 June 1951
 Biennali e Premi in *Minosse*, Venice, 17 November 1951

1952 *Pittura e Modernismo* in *Giornale d'Italia*, Rome, 3 August 1952
 Non Reggono più le Stampelle del Surrealismo in *Giornale d'Italia*, Rome, 28 September 1952
 SOS dei Modernisti in *Il Giornale d'Italia*, Rome, 7 October 1952
 Cézanne e Van Gogh in *Il Giornale d'Italia*, Rome, 30 October 1952

 Non Fisco ma Fiasco in *Il Giornale d'Italia*, Rome, 21 November 1952
 Il Virus Modernista e la Decadenza dell'Arte Sacra in *Il Giornale d'Italia*, 11 December 1952

1953 *Made in France* in *Il Giornale d'Italia*, Rome, 8 February 1953
 Il Mistico Zelo di Certi Espositori in *Il Giornale d'Italia*, Rome, 19 March 1953
 Lo Snobismo contro l'Arte in *Il Giornale d'Italia*, Rome, 10 April 1953
 Nel I Anniversario del Morte de Savinio (published under the pseudonym Dr Fausto Bima) in *Il Giornale d'Italia*, Rome, 7 May 1953
 Il Modernismo è Arte Borghese in *Il Giornale d'Italia*, Rome, 23 June 1953
 Un Pittore senza 'Arie' in *Giornale d'Italia*, Rome, 21 October 1953

1954 *Il Ratto di Derain* in *Il Giornale d'Italia*, Rome, 26 March 1954
 Pittori senza Pseudo Inquietudini in *Il Giornale d'Italia*, Rome, 10 April 1954
 Controrivoluzione in *Il Giornale d'Italia*, Rome, 24 April 1954
 Biennale Dittatoria in *Il Giornale d'Italia*, Rome, 4 November 1954
 Contro Mercanti Internazionali in *Il Giornale d'Italia*, Rome, 1954(?)

1955 *Il Caso Derain* in *Il Giornale d'Italia*, Rome, 23 March 1955

1958 *La Biennale di Venezia non Mi Incanta più* in *Candido*, Milan, 13 July 1958

1960 *Psicoanalisi del Modernismo* in *Candido*, Milan 3 July 1960
 Le Vittime di una Ostinate e Perfida Propaganda in *Candido*, Milan, 17 July 1960
 Settant'Anni di Progressivo Crollo par l'Arte in *Candido*, Milan, 24 July 1960
 Propaganda Frenetica ma che Perde le Staffe in *Candido*, Milan, 4 September 1960
 Continua in Italia il Servilismo nei Confronti della Pseudopittura Francese in *Candido*, Milan, 2 October 1960
 Ecco che Cos'è l'Arte Modernista in *Candido*, Milan, 6 November 1960

1961 *Poesia e Pseudopoesia, Scemenza Mondiale el Esterofilia Italiana*, in *Candido*, Milan, 6 November 1960
 Il Francesi Vogliono Istruirci in *Candido*, Milan, 26 March 1961
 Le Grottesche Menzogne di Time in *Candido*, Milan, 9 April 1961

1964 Preface to *Giovanni Stradone*, Rome 1964

1973 *Wir Metaphysiker – Gesammelte Schriften*, edited by Wieland Schmied, translated into German by Anton Henze, Berlin, 1973

A comprehensive bibliography of books and catalogues on de Chirico covering the period 1919–82, can be found in the catalogue published by the Pompidou Centre on the occasion of the de Chirico retrospective in 1983.

Arnolfini Gallery, Bristol: 2 March – 7 April 1985
Museum of Modern Art, Oxford: 14 April – 2 June 1985
Mappin Art Gallery, Sheffield: 22 June – 21 July 1985
Riverside Studios, London: 30 July – 1 September 1985

The Mysterious River 1969
lithograph

Exhibition selected by Rupert Martin and Carmine Siniscalco
Translations from the Italian by John Mitchell, from the German by Andrea Schlieker
Photographs of Giorgio de Chirico by Walter Mori
Designed by Richard Hollis
Printed in Great Britain by Raithby Lawrence, Leicester and London

Published by Arnolfini Gallery, Bristol 1985

© The authors and Arnolfini Gallery, Bristol 1985
The article by Stephen McKenna,
Pictor Classicus Sum: Giorgio de Chirico, Integrity and Reaction
is published by kind permission of Artefactum, Antwerp

ISBN 0 907738 12 5

Gallery Staff:
Gallery Co-ordinator: Rupert Martin
Exhibitions Assistant: Andrea Schlieker
Administrative Assistant: Claire Anderson
Education Liaison Officer: Jenny Lockwood
Gallery Technician: George Coulsting

A list of all Arnolfini catalogues in print can be obtained from
the Bookshop, Arnolfini, Narrow Quay, Bristol BS1